Journal

A MOTHER AND DAUGHTER'S
RECOVERY FROM BREAST CANCER

For my mother
and in loving memory of my grandmother,
Rachel Kempson Redgrave
1910-2003
—A.C.

JOURNAL

A MOTHER AND DAUGHTER'S
RECOVERY FROM BREAST CANCER

Photographs by Annabel Clark Text by Lynn Redgrave

Introduction by Dr. Barron Lerner

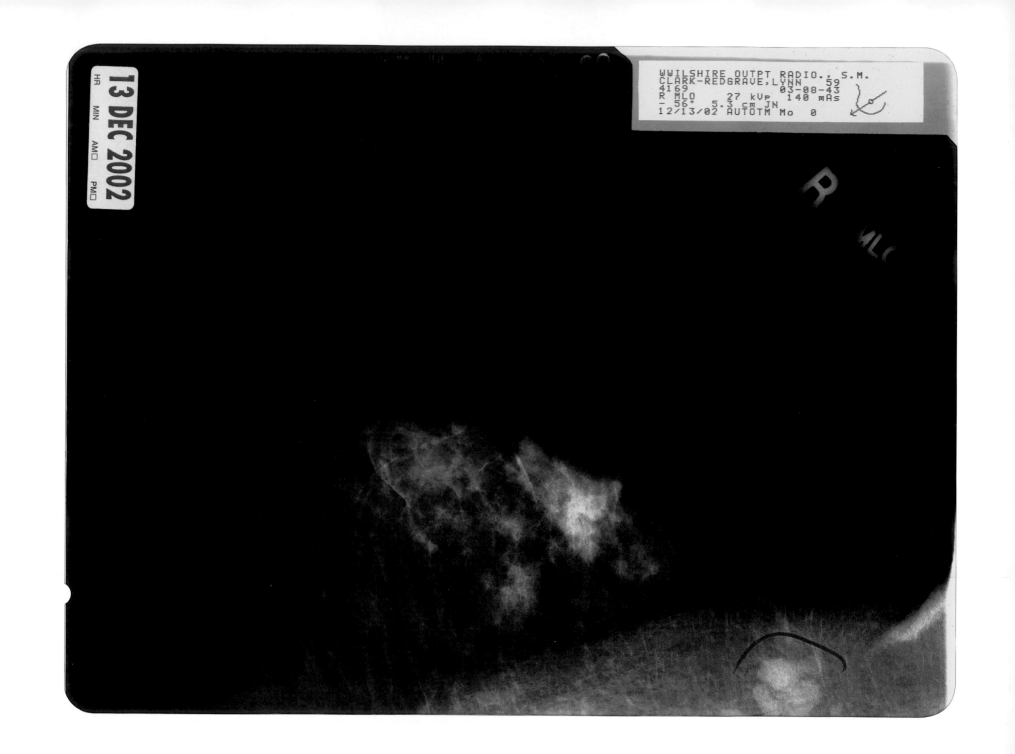

Introduction

If, thirty years ago, someone had asked Lynn Redgrave if she would one day visually depict her personal experiences with breast cancer to millions of people, she surely would have said no. Circa 1974, cancer was an intensely private event shrouded in fear and shame. But times were changing. In that year, both Betty Ford and Happy Rockefeller went public with the details of their fights with breast cancer, alerting women about both early detection and treatment options. And women such as Betty Rollin, believing that breast cancer was nothing to be ashamed of, began to openly discuss the disfigurement that accompanied a mastectomy.

By the 1990s, a vibrant breast cancer activism movement had emerged, further educating the public about the disease and successfully lobbying Congress for increased research funding. To be sure, breast cancer was still a fearsome disease. It was (and remains) the most common non-skin cancer in American women, causing over 200,000 new cases and killing roughly 40,000 women annually. But due to growing use of mammography and better treatments, the death rate from breast cancer, which had stubbornly remained stable for decades, had finally begun a gradual and steady decline.-

Essential to the new breast cancer activism has been visual imagery. We have grown increasingly accustomed to seeing women with breast cancer organizing rallies, proudly displaying pink ribbons, discussing their disease on national television and even revealing mastectomy scars. These latter images have often been political statements, asserting that women who lose their breasts are no less vital and beautiful than they were before their illnesses. But such pictorials are also highly individual stories of how women—both famous and previously unknown—have endured, and often triumphed, over a perilous foe. It is in this tradition that we now meet Lynn Redgrave, a renowned actress, shirtless and bald in front of her daughter's camera lens.

It is difficult to know how women who had breast cancer prior to the 1970s responded to their disease. Few wrote publicly about their experiences, although some confided to their diaries. One such woman was the English novelist Fanny Burney, who penned a devastating account of her 1811 mastectomy, performed without anesthesia, which had not yet been invented. "When the dreadful steel was plunged into the breast," she wrote, "cutting through veins—arteries—flesh—nerves—I needed no injunctions not to restrain my cries. I began a scream that lasted intermittently during the whole time of the incision." Happily, Burney's sufferings were rewarded. She lived until 1840, dying at the age of eighty-eight.

> Such pictorials are also highly individual stories of how women—both famous and previously unknown—have endured, and often triumphed, over a perilous foe.

Another woman who underwent a mastectomy in 1811 was Abigail Adams, known as "Nabby," who was the daughter of John Adams, the former president of the United States. As was often the case in this era, Adams tried to downplay the breast lump that she first discovered in 1809. It was not until two years later that she would be diagnosed with breast cancer and receive a mastectomy from John Warren, a famous Boston surgeon. Adams later termed the operation a "furnace of affliction," but wrote that it was a "blessing … to have extirpated so terrible an enemy." Unfortunately, by the next year the cancer had recurred throughout her body. Knowing that she would not recover, she chose to return to her parents' house in Quincy, Massachusetts. She died there on August 9, 1812 at the age of forty-two.

Adams' story resembled those of most women in the nineteenth century. Due to shame, ignorance, wishful thinking or a combination of the three, women generally let their breast cancers grow to a very large size. By the time they underwent surgery, there was little or no chance of cure. But one man hoped to stop this state of affairs. He was William Stewart Halsted, a brilliant if eccentric surgeon at Johns Hopkins University, who popularized an operation known as the radical mastectomy.

In this operation, the surgeon removed not only the affected breast and underarm lymph nodes, but both chest wall muscles on the side of the cancer. Halsted believed that breast cancers spread in an orderly manner, remaining in the breast for a long period of time and then gradually spreading to the surrounding tissues. A large enough operation, therefore, might encompass all of the cancer cells and thus cure the patient. Although later vilified as a "butcher" of women, Halsted and his operation brought hope to thousands of desperate patients when there had previously been none.

6

What fewer people recall about Halsted were his entreaties for women and their doctors not to ignore potential breast cancers. By the 1910s, the American Society for the Control of Cancer (later the American Cancer Society) had embraced this message, listing a breast lump as one of its so-called danger signals. "Do not delay," stated anti-cancer publicity, urging women to see their physicians as promptly as possible.

By the 1950s, activists had begun to stress the importance of monthly breast self-examinations, which could identify smaller, presumably more curable, tumors. This campaign produced "how-to" instruction manuals, which contained what were among the first photographs of women and their bare breasts deemed fit for public consumption. While the ability of breast self-examination to prevent cancer deaths remains a subject of intense debate, the publicity surely helped women grow more knowledgeable about the subject of breast cancer.

Doctors routinely concealed the diagnosis of breast and other cancers from patients, believing that frank disclosure would cause loss of hope and thus earlier death.

Still, the 1950s and 1960s remained very quiet decades regarding cancer. Doctors, with the cooperation of families, routinely concealed the diagnosis of breast and other cancers from patients, believing that frank disclosure would cause loss of hope and thus earlier death. Instead, physicians used euphemisms such as "tumor," "growth," and "inflammation," even among patients undergoing aggressive surgery and radiotherapy. "She has not been told her exact diagnosis," wrote doctors of a woman with metastatic colon cancer in 1959, "but has been told she has a recurrence of her polyp."

All this was to change dramatically beginning in the 1970s. Even before Ford's and Rockefeller's disclosures, a few women went public with their breast cancer stories in women's magazines and on television. Much of the impetus for this activism was a feminist-era reaction to a male medical profession seen as "condescending, paternalistic, judgmental, and noninformative." In publications such as *Our Bodies, Ourselves*, women urged one another to learn about their bodies and take charge of their health care. In the world of breast cancer, this meant questioning one's physician about treatments less deforming than the radical mastectomy. Describing her refusal of radical surgery in *The New York Times* in 1972, one such woman, Babette Rosmond, stated that "I think what I did was the highest level of women's liberation. I said 'No' to a group of doctors who told me, 'You must sign this paper, you don't have to know what it's all about.'" By 1990, sixteen states had actually passed laws mandating that physicians inform women of all treatment choices for breast cancer.

Meanwhile, other women began to address a series of issues that had long been seen as embarrassing: the impact of mastectomy and other breast cancer treatments on emotions, body image, and sexuality. Among the earliest women to raise such concerns was Terese Lasser, a New Yorker who was surprised to find these topics to be off-limits after her 1952 mastectomy. Lasser would eventually establish Reach to Recovery, a program in which breast cancer survivors visited women shortly after their mastectomies, providing information about exercises (hence the use of "reach" in the organization's title), breast forms, brassieres, and sexual intercourse. Lasser's troops were instructed to proudly wear tight-fitting blouses and challenge their pupils to select which of the volunteer's breasts had been removed.

Radical for its time, Lasser's approach, which stressed optimism and a return to normalcy, was nevertheless becoming dated by the 1970s. When NBC television correspondent Betty Rollin wrote *First, You Cry* in 1976, she revealed what most women experienced upon loss of a breast: immense sadness. And, Rollin stressed, the disfigurement could not be wished away. When she first viewed her mastectomy scar, she wrote, "I felt ugly and freaky; that anybody who saw me would be repelled and revolted the way I had been." Rollin also frankly discussed her personal life after her bout with breast cancer, which included leaving her husband and beginning an affair with another man.

Women began to address a series of issues that had long been seen as embarrassing: the impact of mastectomy and other breast cancer treatments on emotions, body image and sexuality.

Even though Rollin acknowledged the repercussions of her mastectomy, she also underscored a point made by Lasser: it was acceptable, even necessary, for women with breast cancer to care about how they looked. Prior to her operation, which was a modified version of the radical mastectomy, Rollin had told her surgeon, "I would like to not be very hideous if that's possible." Appearance was especially important for Rollin, a television performer, but it mattered to other women as well. "You would think (being seventy-seven) that I wouldn't be so vain," one woman wrote to Rollin. "But that's the way it is."

Audre Lorde pushed the envelope yet further in her 1980 book, *The Cancer Journals*. As was the case with Rollin, appearances were important for Lorde, a lesbian

African-American poet and English professor. But Lorde rejected the idea that the goal of rehabilitation should be a return to one's pre-operative state. Breast cancer, she argued, was not a "cosmetic problem" that could be solved by a "prosthetic pretense."

Breast cancer was not a "cosmetic problem" that could be solved by a "prosthetic pretense." Lorde eschewed both breast forms and breast reconstruction in favor of a chest wall that reflected and reminded her of her experiences with the disease.

Thus, Lorde eschewed both breast forms and breast reconstruction in favor of a chest wall that reflected and reminded her of her experiences with the disease.

Despite this growing concern with the cosmetic effects of mastectomies, the discussion was largely a literary one at this point. Pictorial representations of post-operative chest walls, beyond their depictions in medical textbooks, remained scarce. This is not to say that images of women with breast cancer did not exist. Among Rembrandt's most famous works is "Bathsheba at Her Bath," a 1654 nude portrait of his mistress, Hendrickje Stoffels. Some physicians who have viewed the painting have identified a cancer in her left breast, which they have hypothesized was the cause of her death.

But it was not until Deena Metzger that a woman chose to broadcast her personal experience with breast cancer through photography. In 1979, Metzger, a writer and counselor, appeared in a photograph, entitled "Tree," in which she gazed joyously at the sky with outstretched arms. Metzger was unclothed above the waist, revealing a mastectomy scar covered by a tattoo of a tree. The picture was subsequently reproduced in numerous feminist publications, including *Our Bodies, Ourselves* and *Her Soul Beneath the Bone*, a 1988 book of poetry on breast cancer.

As art historian David A. Lubin argues in his recent book, *Shooting Kennedy*, images acquire meaning by their associations with earlier, familiar visual representations. Such was the case with "Tree." Metzger's pose explicitly drew on the legend of ancient Greek women who supposedly had a breast removed to improve their ability to hunt with a bow and arrow. "I have the body of a warrior who does not kill or wound," Metzger wrote in a poem that accompanied the photograph.

Metzger's political statement—that breast cancer should evoke power and not shame—went mainstream in 1993 when the model Matuschka bared her mastectomy scar on the cover of *The New York Times Magazine*. The accompanying caption, "You Can't Look Away Anymore," heralded a surge of breast cancer activism in the 1990s that would make the disease a household topic and the recipient of hundreds of millions of dollars of research funding. The fact that Matuschka was a model reminded readers that she was no less beautiful for having lost a breast.

Not everyone embraced the new boldness that induced some women with breast cancer to "bare it all." When the University of Illinois Press, publishers of *Her Soul Beneath the Bone*, wrote to veteran breast cancer activist Rose Kushner about using "Tree" on the book's cover, Kushner scribbled the words "very negative" on the letter. A reader of *The New York Times* upbraided the newspaper for using anger and "shock therapy" to push for a breast cancer cure. Still, the responses to such photographic collections have usually been positive, as with the breast cancer survivor who wrote of the Matuschka cover: "Fantastic! A cover girl who looks like me."

Annabel Clark's photographs of Lynn Redgrave, which first appeared in *The New York Times Magazine* on April 18, 2004, break new ground. Although many

women celebrities since Betty Ford have gone public with stories of their breast cancer, none has participated in such a vivid pictorial representation of her experiences. The fact that Redgrave is a world-renowned actress matters. Americans are passionate about celebrities, even at times feeling closer to them than to members of their own families. And due to their fame and wealth, critic Richard Schickel has written, celebrities appear to be their own bosses—masters of their fate. This sense of control can be very reassuring for a woman fighting her own breast cancer. "I feel that my treatment will work," Redgrave wrote in her journal on February 18, 2003. "I have faith. I am so lucky to know what all this side of life is." Such words, coming from Redgrave, are surely inspirational for other women with breast cancer.

Twelve months after finding her lump, Lynn Redgrave celebrates a full year of "fear and joy and courage."

Yet what may be most powerful about the photographs of Redgrave are their ordinariness. True, as a public figure, Redgrave had access to excellent medical care and even appeared in plays during her treatments. But as with other pictorial essays of women with breast cancer published after the Matuschka cover, the photographs of Redgrave are less political statements than works of narrative art, documenting the vicissitudes that necessarily accompany an encounter with the disease: the shock of diagnosis, the side effects of therapy, the milestones of survival, and the loving support systems that women construct.

In the photographs, Redgrave laughs and cries. She studies the breast she will lose and bids it farewell. She looks at her mastectomy scar and pronounces it "not bad at all." She relaxes with her loving daughter. She sits at the hospital receiving chemotherapy and radiotherapy. She celebrates a birthday with a "smiley" balloon. She visits with her mother and her sister, Vanessa. She studies her bald head while sitting in bra and panties. She buys a dog. She buries her mother, who has died from a stroke. She watches her hair start to grow back. She chooses, like Audre Lorde, not to undergo reconstruction. And, twelve months after finding her lump, she celebrates a full year of "fear and joy and courage."

So while the Lynn Redgrave of 1974 would never have imagined publicizing her breast cancer to the world, for the Lynn Redgrave of 2004 it could be no other way. "Having cancer treatment is LIFE AFFIRMING," Redgrave wrote in her journal on July 1, 2003. "I am now truly living in the moment."

But the images of Redgrave also speak to the future. While much has been accomplished in the world of breast and other women's cancers, much remains to be done. In order to lower rates of these diseases, we need to learn more about how genetic and environmental factors combine to cause cancer. In order to lower the death rates further, we need better, nontoxic treatments. And in order to continue to overcome fear, stigma and ignorance, we need more women to come forward as Lynn Redgrave has, showing us how living with disease can be a rich and life-affirming experience.

—Dr. Barron H. Lerner, June 2004
author of *The Breast Cancer Wars*

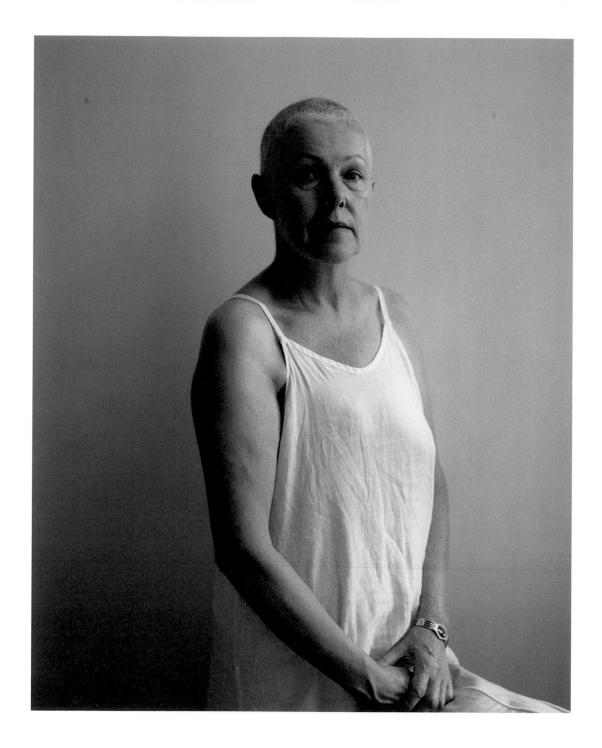

Photographer's Foreword

21 December 2002. Tired and hung-over after a post-Christmas party cleanup at my friend's house, I decided to give my mother a quick call. She had left a message saying she wanted to tell me something. I imagined that she wanted a consultation on my sister's Christmas present, or that she was going to give me the train schedule to her house that afternoon. When she picked up, I had no idea how much this conversation would change us and our relationship. "Now I don't want you to worry just yet," she said. "But I found a lump and I had some tests which came back positive…" Cancer.

I stopped outside the subway and cried as she reassured me that it would be OK, that she had the best doctors around, that she was going to have surgery to remove the lump and possibly chemotherapy, but that she thought she caught it early enough. It didn't change the impact of her using words that should never have been applied to such a healthy woman. The words "breast cancer" and "chemotherapy" and "mastectomy" were scary and unfamiliar to me. I could not associate these words with my mother. They stirred up images of bald and emaciated women attached to tubes and needles and hospital beds. They brought up memories of my friend's mother, who had died of breast cancer and of her funeral back in high school. But as the news slowly sunk in, I knew I would have to find a way to confront the disease as she wanted to—with as little fear as possible. And then, as the idea was forming, she read my mind. She asked if I would photograph her.

At the time, I was halfway through my senior year at Parsons School of Design as a photography major. For three years I had been shooting portraits of my family and friends, but nothing so far had really struck me as a subject I felt compelled to photograph. This did. It seemed like the natural thing to do. If we turned the disease into a project, it would become less scary. We could objectify it and observe it. And if we could anticipate the completion of the project, then we could anticipate the end of the disease.

I hadn't taken many pictures of my mother before she got sick. As an actress, she was a natural in front of the camera and had been photographed by so many professional photographers that I guess I didn't feel the need to take my own. In fact, one of the first times I asked to take her portrait was on that previous Thanksgiving. We went out onto the balcony in the late afternoon light, and I unknowingly shot the first picture of the project. Two weeks later, she was diagnosed.

11

That holiday season, instead of celebrating the baby growing in my sister's belly, we worried over the lump growing in my mother's right breast. Those few weeks of waiting were the hardest, because on the outside, nothing had changed. We could only try to imagine the transformation that was about to occur.

The day before surgery, I accompanied my mother to the hospital with her best friend Carry. While we sat in the waiting room, a pale young girl with no hair was wheeled past my mother, who in comparison still looked so healthy and beautiful. She didn't belong here. We walked into a dimly lit room filled with machines and computers devoid of warmth or personality. Nothing really made sense. What did these big machines actually do? What did the numbers on the screen mean anyway? I shot everything in black and white before the surgery and, looking back, don't remember if there was any color to be seen in those rooms.

The next morning, we had to be at the hospital at 5:45 am. We were deliriously upbeat, trying to distract her and ourselves from the fear of the unknown. When she was taken into the operating room, her friends, my brother, and I waited in her hospital room. I lay in her bed. And we waited.

Hours later, Carry and I went down to the recovery room. She was out cold. The fear settled in. Even though they had removed the lump and she was supposedly cancer-free, this was the first time she looked sick. She lay unconscious in her hospi-

tal gown, attached to tubes and needles and a hospital bed. I realized I had left the camera in her room, but it didn't matter. I wouldn't have been able to focus if I tried.

For two days in the hospital she was forced to relax. Do nothing. We read trashy magazines and watched escapist TV shows together. By the time she was allowed to leave, she was going stir crazy. Less than twenty-four hours after her surgery she was talking about working again. It was the only way in her mind she would be able to get through the next six months. After only a few days of taking pictures in the hospital, I knew that continuing to photograph her throughout recovery was the only way I would make it. So I brought my camera with me every time I went to see her. She stopped noticing it after awhile, and I knew that nothing was off limits.

I continued to photograph her throughout chemotherapy, which involved injections at the hospital as well as self-administered injections at home. She lost her hair within weeks and replaced it with two wigs—one to match her hair before it fell out and one to wear for her role in the play *Talking Heads*, which she began performing in March.

It was during this time that my grandmother came from London with my aunt Vanessa, who was starting a six month run of *Long Day's Journey Into Night* on Broadway. Another mother/daughter story began to unfold in front of me. My grandmother had been suffering from dementia for a number of years, so my mother

chose not to tell her about her own illness. Instead, she spent as much time as she could with her, knowing that their days together could be limited. I photographed their interactions and empathized with what my mother was going through. She was dealing with her own feelings about her mother's mortality. My grandmother passed away during her stay in New York, and while this brought our fear of death to the surface, we felt lucky that she went quietly and peacefully, surrounded by her children without the burden of knowing that one of her daughters was battling cancer.

It has been over a year since I began photographing my mother, and while the project itself remained a private outlet for recovery in both its content and intention, we felt that by sharing it, we could help other people going through breast cancer. I knew that she had always kept a journal, and I saw her writing in one throughout treatment. So I asked to use her words to give the photographs a voice and with her permission, put together a book of images accompanied by her text. The handbound book and eight enlarged prints were included in the Parsons Senior Exhibition in April 2003. She attended the opening and stood proudly in front of the images wearing the same wig that appeared on the wall in front of her. People came up to us and said we were very brave for doing the project. But she told me afterwards that she disagreed with them. Because in order to be brave, one must also have fear. And after seeing herself on the wall and inside the book, she said she wasn't afraid anymore.

My photographs and her journal entries tell a parallel story of an illness that I now look back on as something we were lucky to go through. While they highlight upsetting moments of vulnerability and hopelessness, they also show her incredible will to overcome this disease with both strength and grace. My mother's will to live has been empowering for me and, I hope, will be for other women and their families who are battling cancer. This experience has shown me who my mother really is, and it has brought us together in ways I never could have imagined. This is *our* journal.

—Annabel Clark, June 2004

JOURNAL

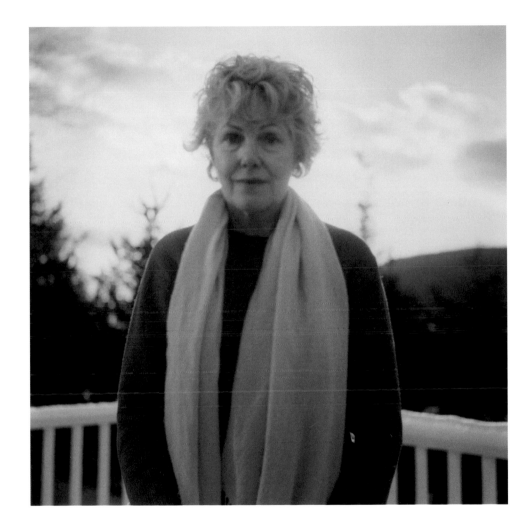

Thursday, 12 December 2002

So about two weeks ago? I think… I had this lumpy feeling under my right arm. I've had it before and it would just go away, thank God. And it did go away but last night in bed in New York, Annabel was next to me and my right breast felt sore and uncomfortable. So I felt around and there was this knotty lump. It's scary. Where did *that* come from? Oh please God, why is it there? Don't let it be. And how many countless women have said that? It can't be, it isn't, oh no. Anyway, tomorrow in L.A. I go to see Dr. Blanchard. I keep feeling it to see if it has gone. But no, it's there. Went very briefly to the web site about breast cancer. It said only thirty percent of lumps are cancer. I don't have time for this. I have my play. I can't have cancer. I can't.

Friday, 13 December 2002

I remember thinking that I didn't really want to go to the dentist on Friday the 13th—Little did I know that I would, after that, be sitting in Doctor Karen Blanchard's office worrying about a lump.

Saturday, 28 December 2002

I've begun imagining what it will be like without my breast. I've pressed it back flat as I look in the mirror. Try thinking forward to it being just a flat thing with a scar. That's what woke me up so early, I think. Just picturing it. I hope I can come here to my Illyria to recover. I'd like to be here—Carry could come and it would be peaceful and right. I will heal and since I have the knowledge, the sure true feeling in myself—how could I not recover from this? I will—it will be my mission. It *will* work. Maybe *all* this—*all* this is to show me, and through me, to show other people that nothing must be taken for granted. Life is this journey and we must try to make each bit count.

Tuesday, 14 January 2003

I feel *so young*. *So well!* How can I have a potentially life-threatening disease? I feel I've been given an extraordinary gift. I am seeing things, colours, senses, the world around me so sharply. I am living *fully* because I am under the possible guillotine of an earlier-than-expected death.

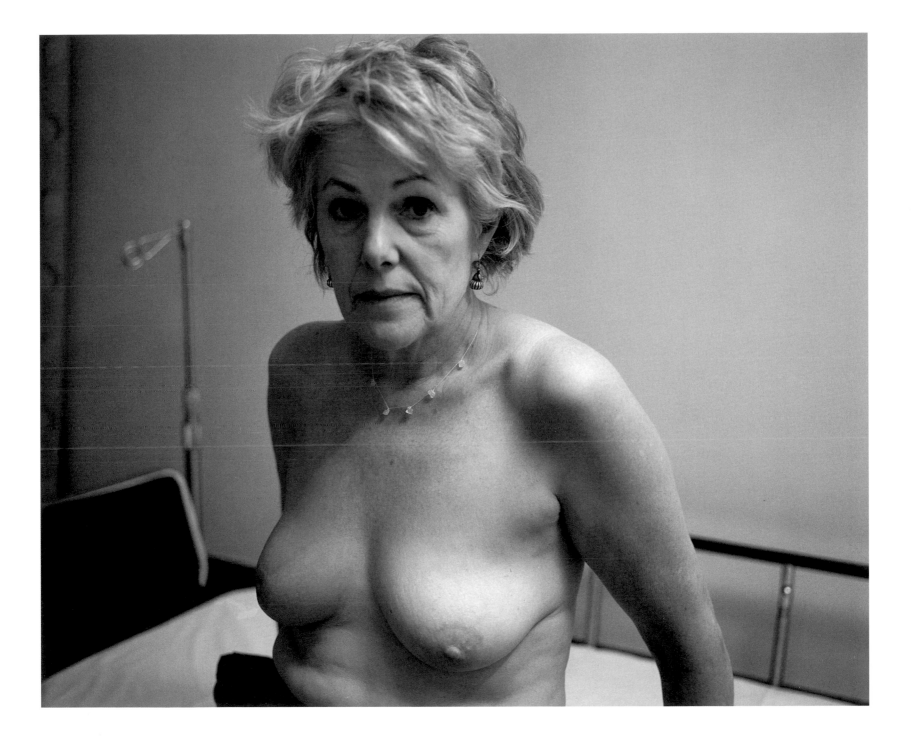

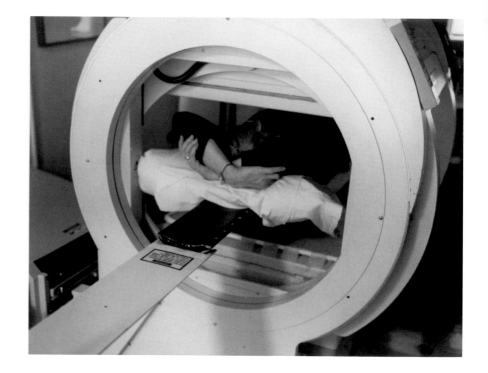

Wednesday, 15 January 2003, 10:55 pm

before bed, the night before

Last supper. One more hour when I can drink water. Tests all day. Tears with my Annabel before the statue of St. Elizabeth Seton in St. Patrick's. Goodbye to a part of me. It's done its job—it's been a good nurturer of my children. It is looking swollen now. And a bit of a funny shape—time to say goodbye.

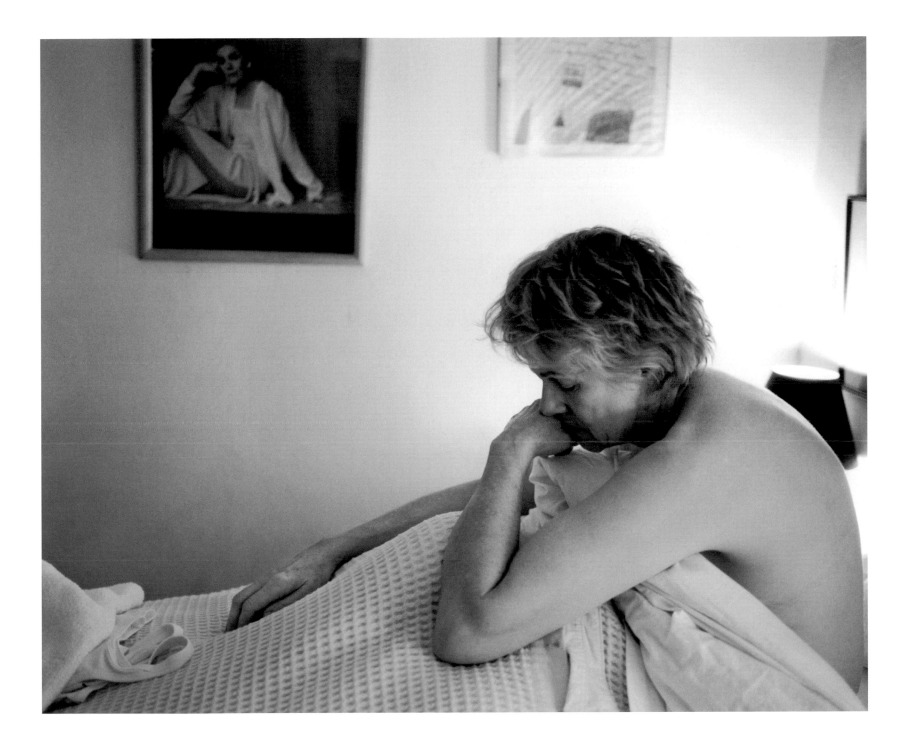

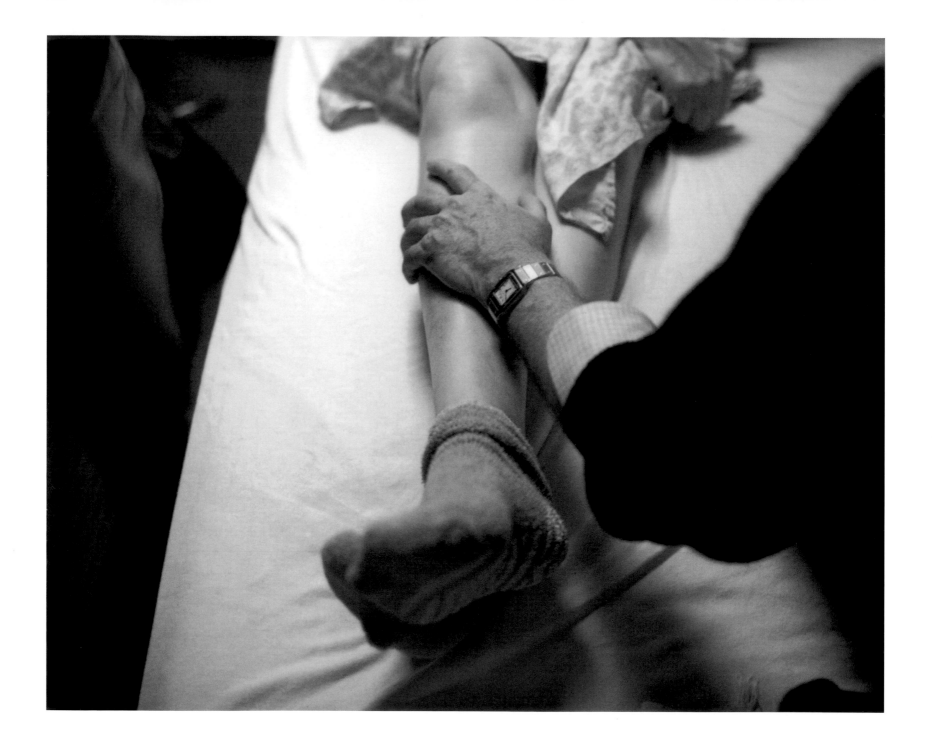

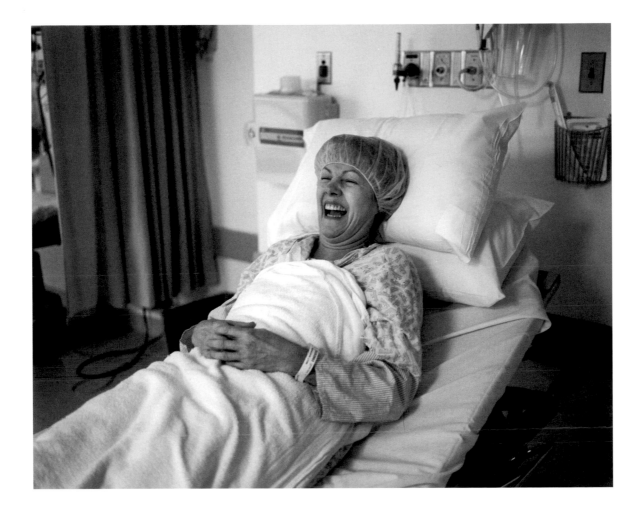

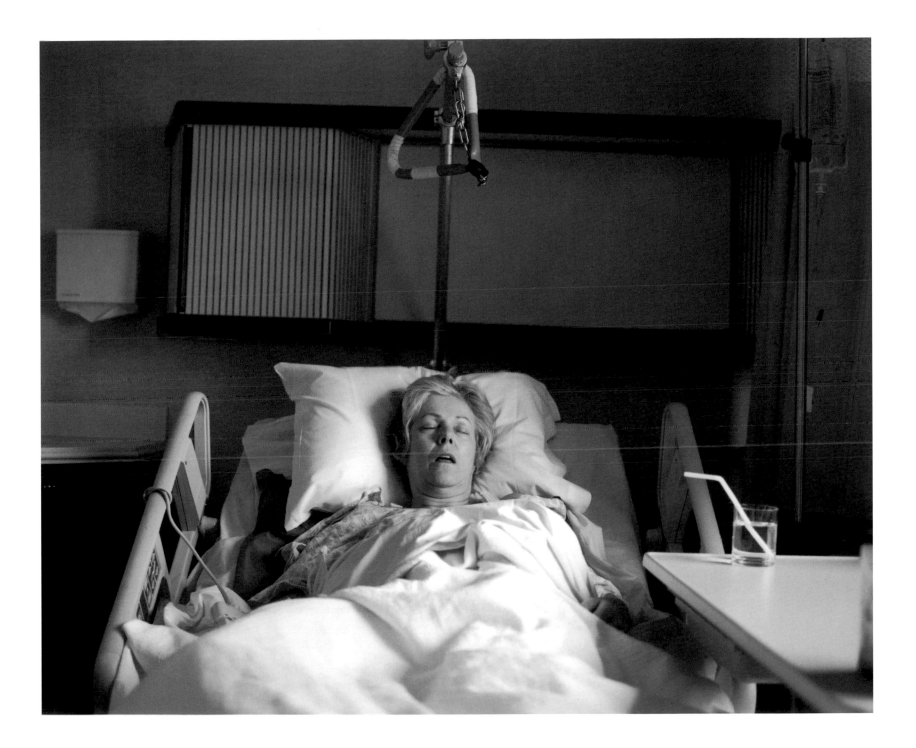

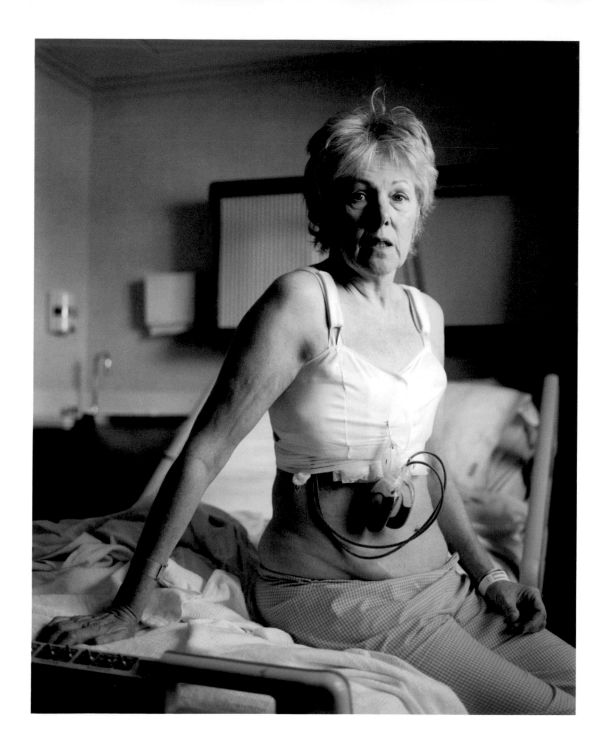

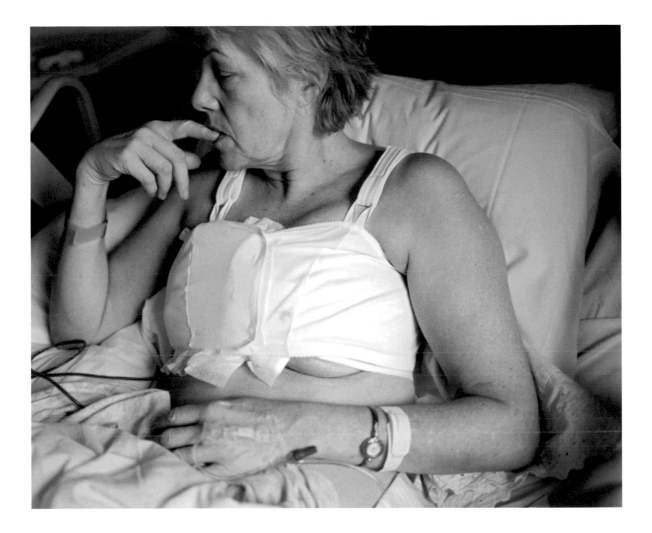

Friday, 14 January 2003

I couldn't write yesterday because I was in Morphine Land. But anyway, my op went fine. Some of the best moments were being with my group waiting to go in. Laughing, loving, then up in the room in and out of consciousness. Benjy came. My beautiful Benjy. My Annabel slept with me on the pull-out chair bed. I've seen my scar—it isn't bad at all. The only worry is what is my future prognosis. How much chemo, etc.

I'm feeling really good—my scar doesn't freak me out—I'm OK—I'm OK. Everyone is so nice here.

Sunday, 19 January 2003

As Annabel and I left the hospital we were helped by William, who had earlier brought me my paper and my breakfast. Waiting for the elevator I started to cry. "One day at a time," he said. "One day at a time. My mom had cancer," he said, "so I've been on both sides of this."

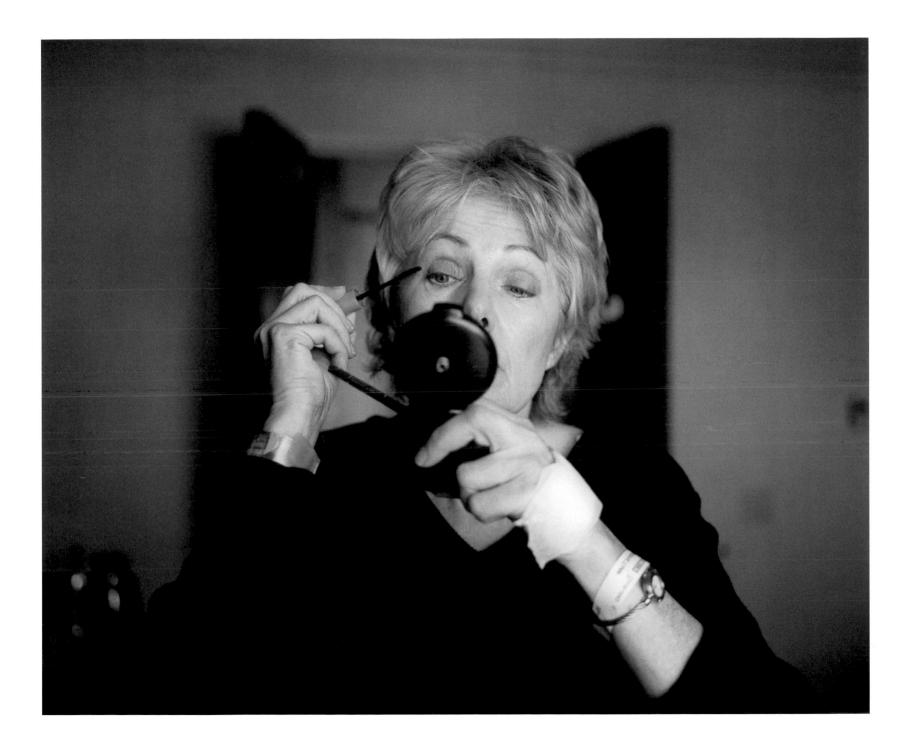

Monday morning, 3 February 2003 — Candles

Slight niggling worry. Yesterday and early this morning—quick, sharp, short electrical impulses—in left back of my head. Tylenol seems to have quieted them but I so seldom get headaches that I am a little worried.

However, that aside yesterday was a wonderful day of healing. Went to the service at the Congregational church. The pastor is *really* good news. I find I cry at first, at Bach on the organ, at prayers. By the end, I feel very peaceful and optimistic. Coffee after and a few hellos to people. A way to be a part of the community. A way to feel I am not alone in my worries. A young woman rose to her feet and asked for prayers for the twenty-six men and women of her husband's unit who have just been deployed to Southeast Asia. It all puts my little battle here in perspective.

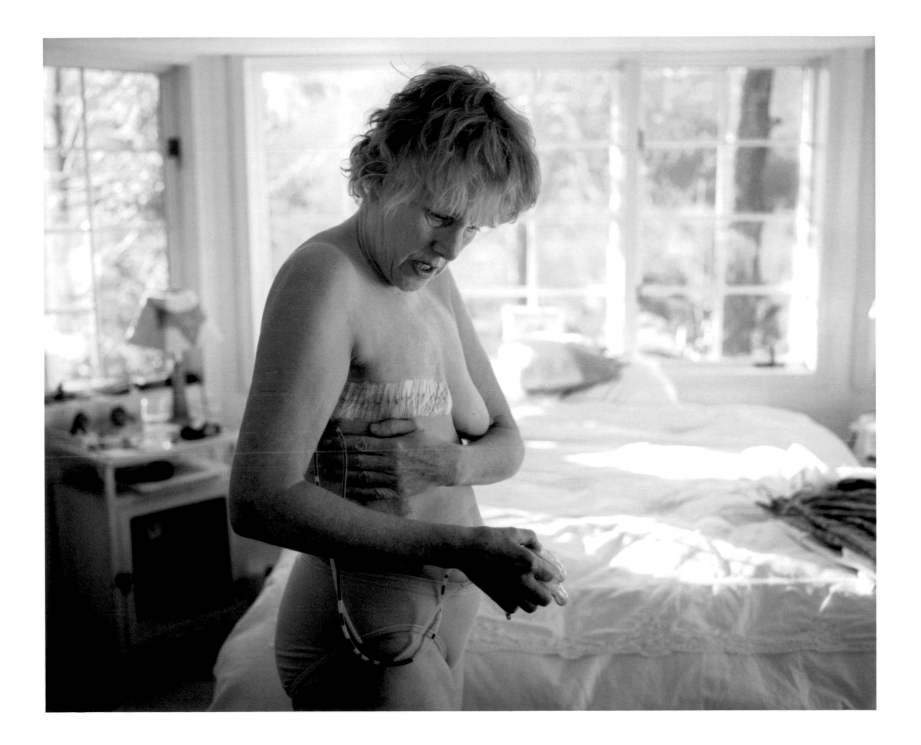

Thursday, 6 February 2003

The drains came out! Oh glory be—Yesterday—

Annabel was with me and a flood of tears erupted from me just as the drains came out and a small flood poured from the holes under my arm…

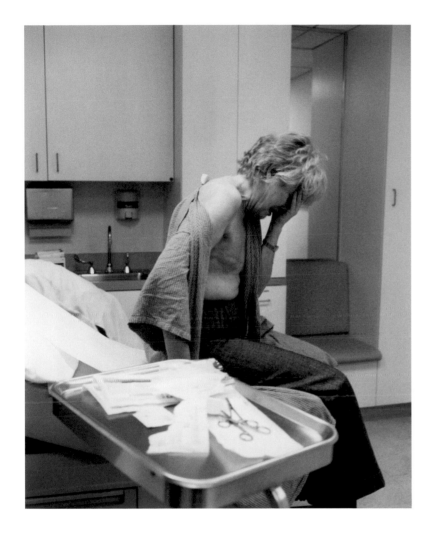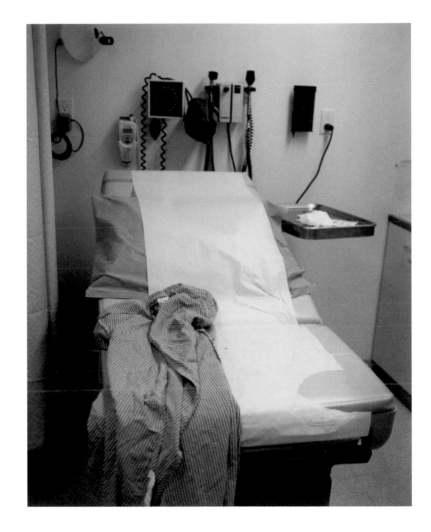

Tuesday, 11 February 2003

After big letdown of yesterday—no chemo, possible infection, taking Cipro—snow falling, talking to Brenda about her experiences, getting depressed and a bit sorry for myself. Snow falling, falling—chest hot—itchy. Concert at Carnegie Hall—falling asleep in second act—mind racing heart sad—lonely—nervous a bit afraid… ALL OF THAT—today I feel much brighter, more energy perhaps I was getting infected.

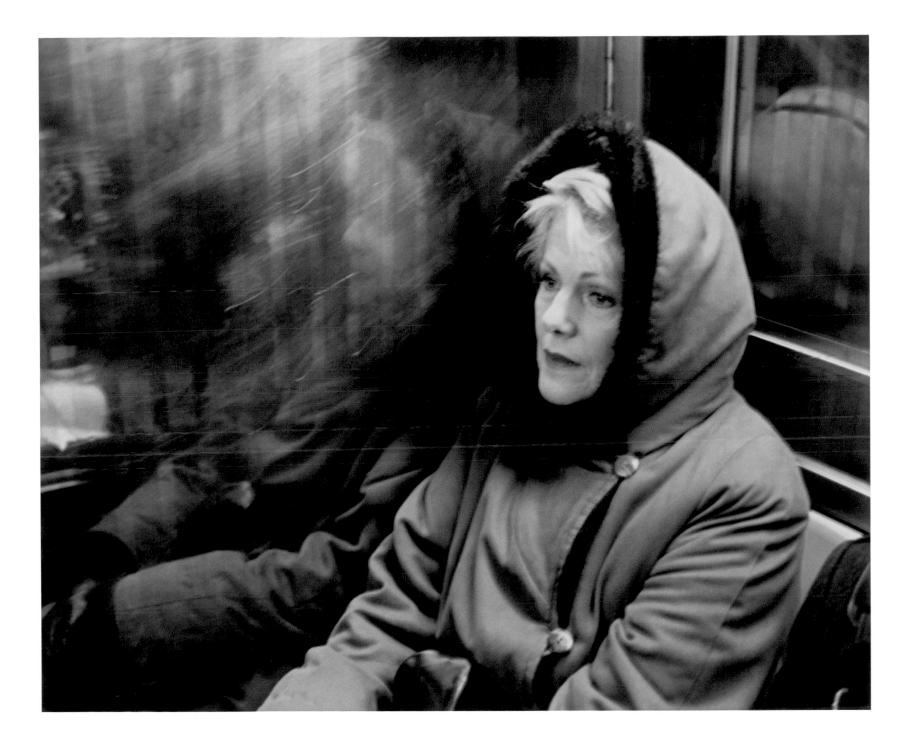

Thursday, 13 February 2003

Yet again no chemo today (I mean yesterday). I will start Monday. Horrible upsetting phone calls regarding Annabel photographing at chemo etc. Thank God that finally got cleared up. I cried so much. I realized how much her documenting this means to me.

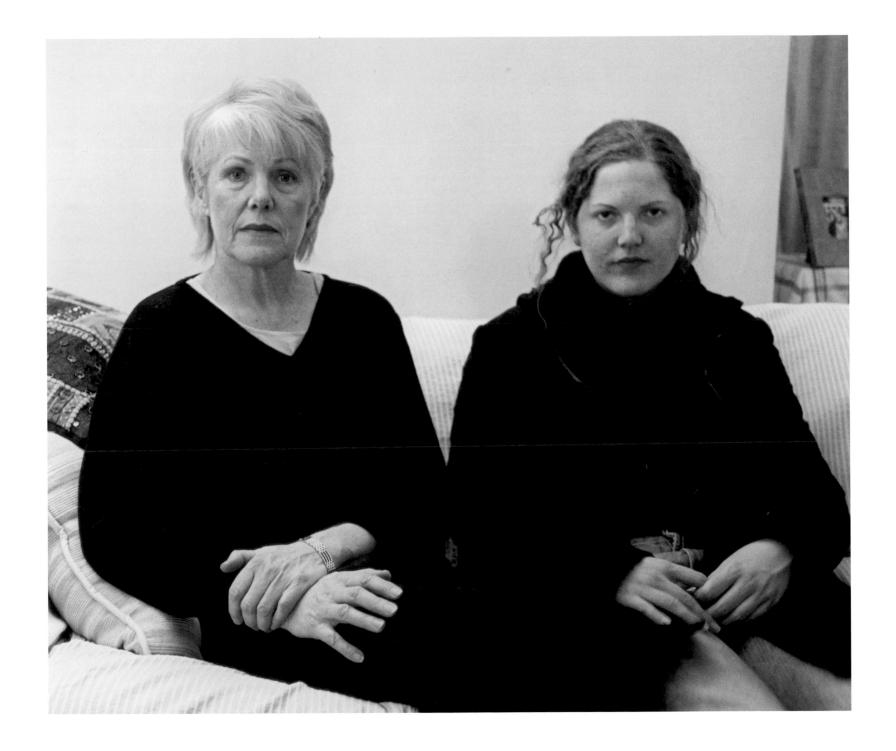

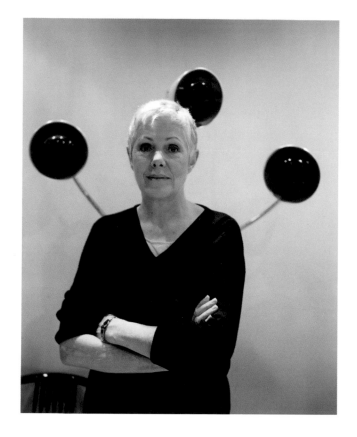

Friday, 14 February 2003 — Valentine's Day

I realize how very susceptible I am, or is it suggestable? I got depressed because I have a head cold and thought maybe I wouldn't start chemo Monday. I *really* want to start and get it over with. Then I called the nurse Maureen and she said no prob, as long as I don't have a fever. So far, I absolutely don't. Bought a new "old fashioned" thermometer. My new exercises are going well. I'm getting a much bigger stretch. Started learning my Miss Fozzard lines in earnest.

Sunday, 16 February 2003

Early, candles…tea…Joan Baez. Just had a good talk with Corin. Yesterday's peace marches—huge and extraordinary but he explained why the war will happen—Last night dins at Ben and Niva's—Delicious— I have my moments of such sadness. They hit me quite suddenly. My loss of innocence. The innocence that made me feel that cancer couldn't happen to me. Tomorrow, at last, I start chemo. It was one month ago that I had my surgery. Jan 16th. Dec 13th the day I knew. I am liking my short hair. Sorry to see it go in a couple of weeks.

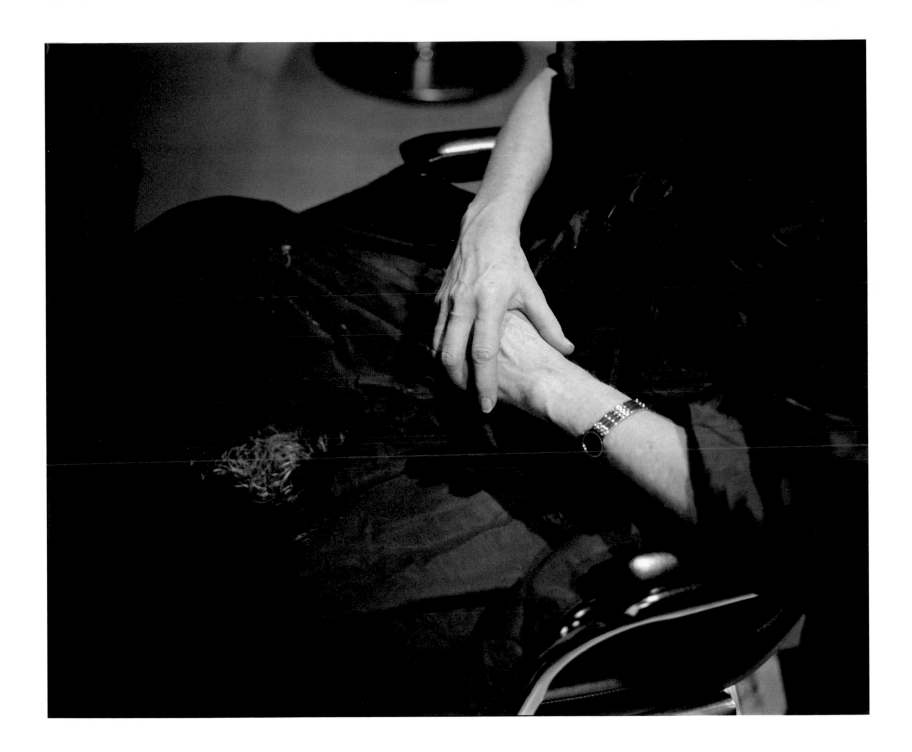

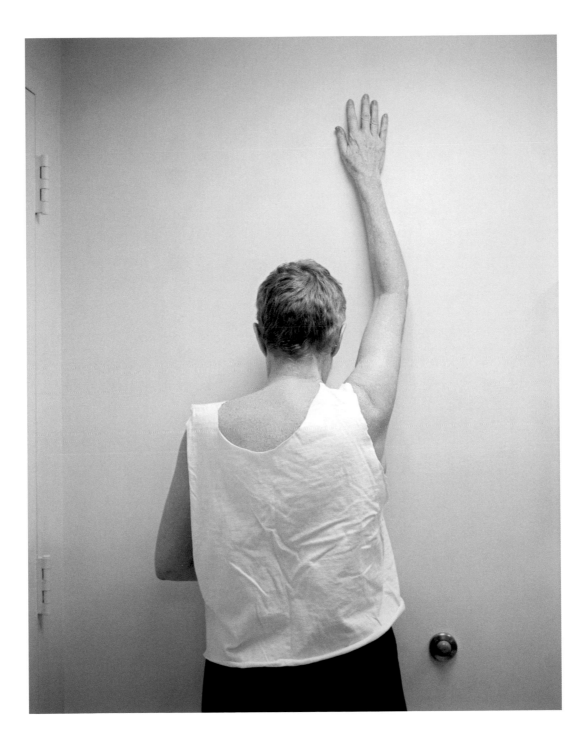

Monday 17 February 2003—THE DAY

The new phase. #1 chemo today plus the biggest blizzard! Annabel and I made it to the hospital in spite of HUGE snow. When we got there we had to wait because some of the staff hadn't made it in yet. I wasn't nervous. It was OK. It didn't hurt, and I played Joshua Bell's "Poeme" album as the needle went into my hand. Annabel was with me. My beloved Annabel. Bought a bathing suit and hat so that I could swim with her in Brooklyn. So far not sick. David brought me a lovely wig. Looks great. I've taken the Adivan—anti-anxiety. It's supposed to make me groggy—Hope to have a big sleep.

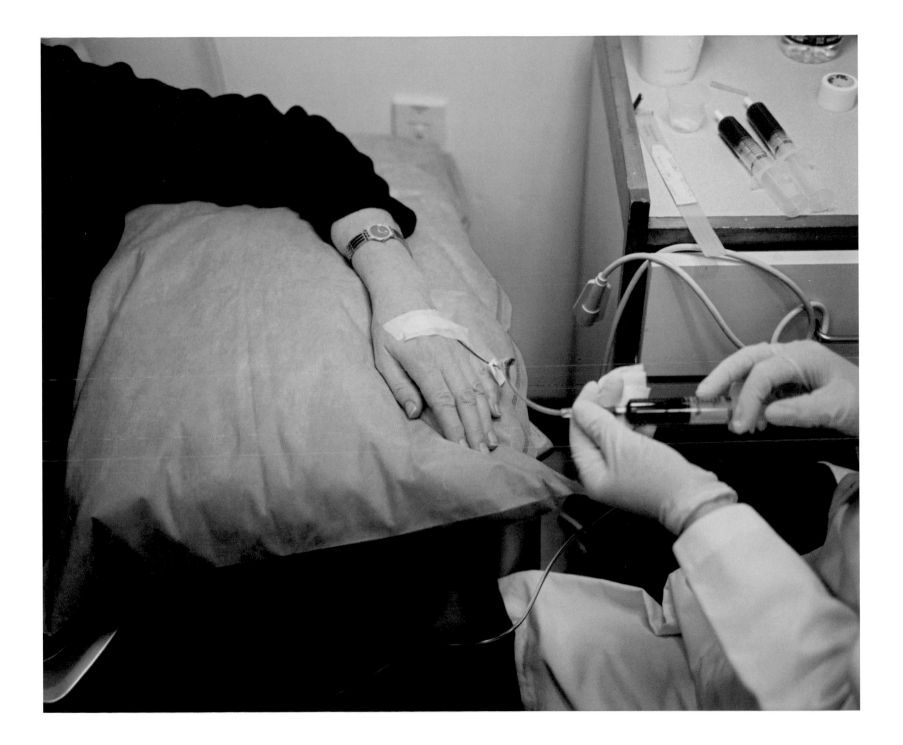

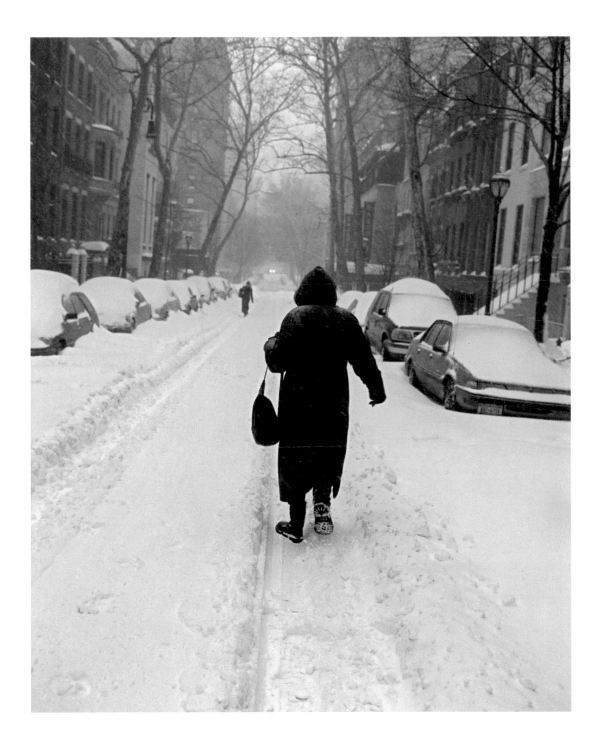

Tuesday, 18 February 2003

And Doctor Theatre starts today with "The Exonerated." Woke 5:15-ish feeling terrific. That slight heady feeling gone. Excited about starting work—Having a schedule.

I'm feeling very positive this morning. Tea, candles, and Nigel Kennedy playing. I feel that my treatment will work. I have faith. I am so lucky to know what all this side of life is.

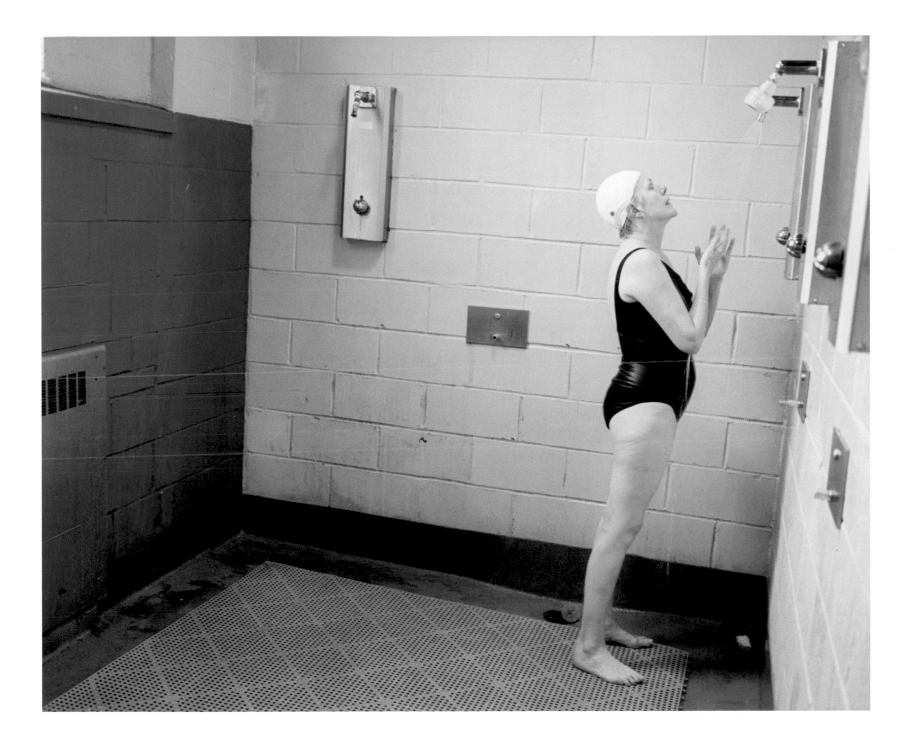

Friday, 21 February 2003

Took two Benadryl last night and slept nine hours. Felt a little groggy but I definitely needed the sleep. My shooting up regime is going OK. #3 this morning. I don't like it but if it means I get through this on schedule, it's worth it.

Saturday, 22 February 2003

The rain beats down—The apartment is lit and my bright gypsyish looking stuff from Anthropologie arrived making my bed so cosy and comforting. But my mood is a little low. I've done my exercises but my scar tissue grips and grabs like a tight iron corset. I don't feel pretty. I feel a little sad.

Sunday, 23 February 2003

Today my heart feels light. Good! It's like I've left behind my sadness over my body. Three more injections to go this session. Maybe my heart is light because I'm going to the country tonight.

Waiting for the 7pm show

Matinee went well. I'm so glad to have this job to come to. I notice an energy drop (e.g., coming to the theatre with my little case packed for the country). By the second set of stairs at the Broadway/Lafayette station, my heart ticks v. fast and my energy seems drained. A nice young woman offers to get it up the last flight. I needed that. Took a Tylenol because my chest bones did hurt and the Neupegin book said that could be a side effect. Tylenol definitely helped. *So* happy to be going to the country. My haven, my peace, my healing.

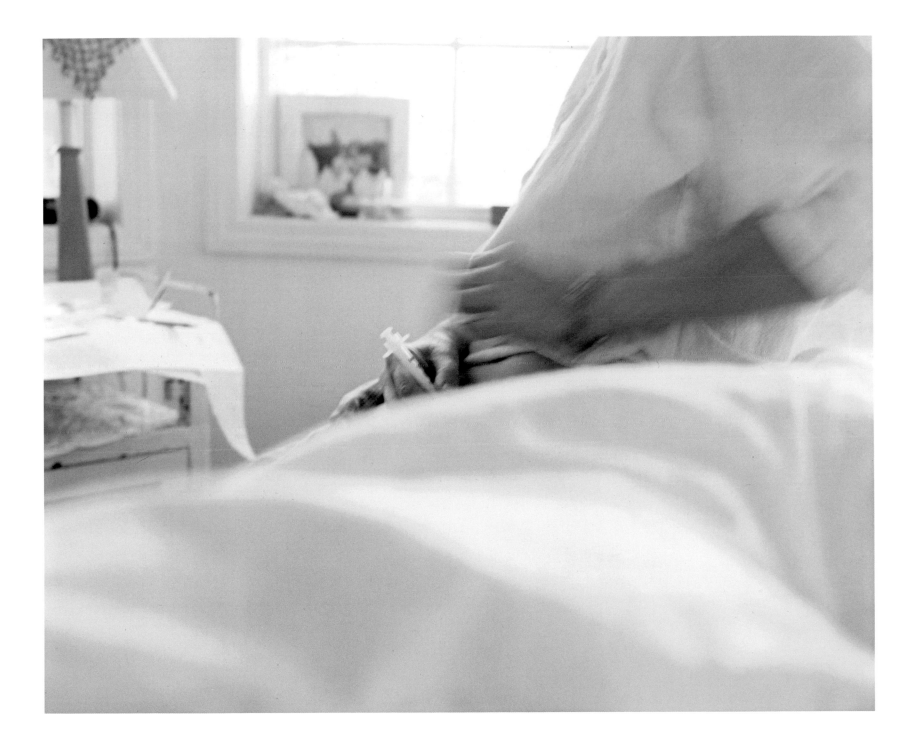

Monday morning, 24 February 2003

Today a day stretches ahead of me to just "be." To do a little pottering. A little resting. Watch a couple of movies. Learn some Miss Fozzard. Take it all in. Love it. Snow is still all over the yard which is so pretty. Nonstop coverage since Christmas.

Tuesday, 25 February 2003

What they didn't tell me about my operation or perhaps I wasn't listening…That the scar tissue would keep squeezing and squeezing. That so much would be numb. Today I did feel a lot of tingling—pins and needles up and down the upper arm. Kind of where I had felt that cold water drip back when I had just had surgery.

Friday, 28 February 2003

Wearing the prosthesis made me feel much more "whole" last night. Happy—real alive.

52

Tuesday, 4 March 2003

Had my second chemo yesterday. Annabel was with me. A nice new nurse called Churly. Interesting that I can write this so far down the page. It was fine. Found my legs a little wobbly weak later in the day—but going off to the party in my wig—red pants and red jacket, made me feel well again and feel as though nothing happened. Just for a while. Long enough. One day at a time. My scalp reminds me of the imminent fall. Quite a few of my white hairs at the front are breaking and falling. I think the rest will go this week according to Churly.

11 am

Just had my shower. More hair coming out.

Friday, 7 March 2003

Loveliest lunch with Vanessa at a nice place on 55th called Michael's. So good to see her. Just what I needed. As I said to her, she keeps turning up like an angel just when I need her most. Like the day I was at MSK and running around having bone scans, etc. Today this morning my depression has lifted. In spite of scary George Bush press conference last night. I'm in positive mode. Rehearsal was excellent. Had steak and veggies. Delish. Slept (w/Ambian) only till four—but already on the case. Anniversary balloons sent to Giles and Kelly for March 11. Laundry on and lines getting learned.

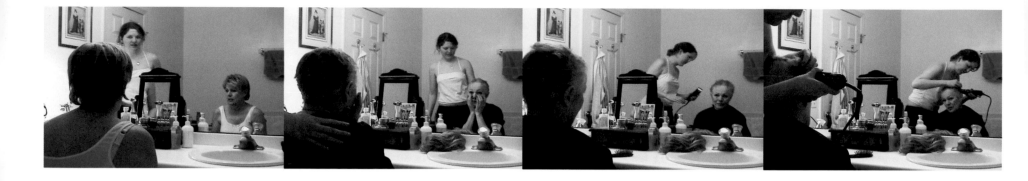

Friday, 7 March 2003

L: OK

A: It's gonna be OK.

L: I know, I know it will… When it comes back, it'll be like a new life won't it?

A: Yeah.

L: *(takes wig off and begins to cry)*

A: It's OK. It's OK, Mom. It's OK.

L: I don't know why it's so hard, angel. I don't know why.

A: Because you don't feel like yourself.

L: I know. That's it. I think. It's true.

A: You're still you.

L: I know my darling. Thank you for all you do for me. And for your love.

A: You're still beautiful.

L: Thank you. *(puts wig down by sink)*. OK. Put that there, shall I?

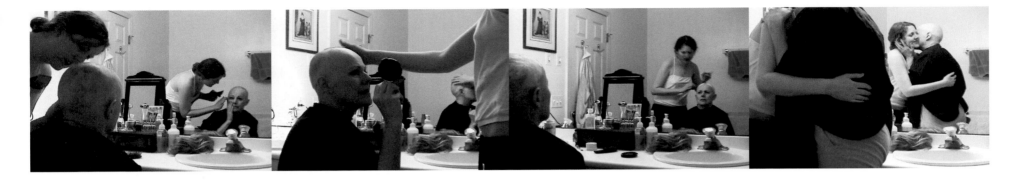

A: Yeah.

A: See, it's better. Don't you feel…

L: Much better. It was the, the patchy pieces that I couldn't bear. And particularly the feel of it in my hands.

A: Mmmm.

L: When it's coming off in the shower, it's, it's like, you can't, it's like your whole self is falling apart. It's just…this is better. This will be much better. I can handle this better.

L: Better. It's gonna be a lot better. It won't be gross. The patchy stage makes you feel like a, I don't know, like you're disintegrating or something. You know. Whereas just clean isn't so bad. I mean, I can get used to that. I've seen some people at the hospital wearing a scarf and they look fantastic, actually. They look really classy.

L: I think I have to discover many, many cute things to do so that I feel cute. I feel horribly uncute right now.

Saturday, 8 March 2003—I'm sixty!

After that upbeat entry yesterday, I got in the shower and my hair really began pouring out. I cried and cried and cried. The feel of it dead in my hands. The bare ridges on my scalp. In spite of it, pulled myself together for a very good rehearsal, then back to the apartment to meet Annabel. We did the train to the country. She went and got the clippers from David and Jeff and we proceeded with the hair thing. Very strange and emotional. So touched and glad that it is Annabel doing it. Seems like a very special mother/daughter thing. The clippers got it very short but you could see the totally bare places still. So then she shaved my head. It does feel *so* much better. I really don't like my look very much but it feels clean at least. Not that sick, dead feel. I wore one of my soft little cotton hats in bed because my head felt cold. And, without drugs, slept from 10:30 pm to 6:38 am. A brief wake-up for a pee and to turn the heat up but I feel so much more myself. That was the thing—I said to Annabel, "Why is this so hard? Why am I so upset about it? It's just hair and it will be back?" She said, "Because you don't feel like yourself." True.

I have a nice little stash of presents to open, which will be fun. I'll do it over breakfast with my angel girl. The sun is out—the snow is deep deep. This week eight more inches fell. The threat of the Iraq war sits in the back of my head bothering me but for today, I'll just live the day.

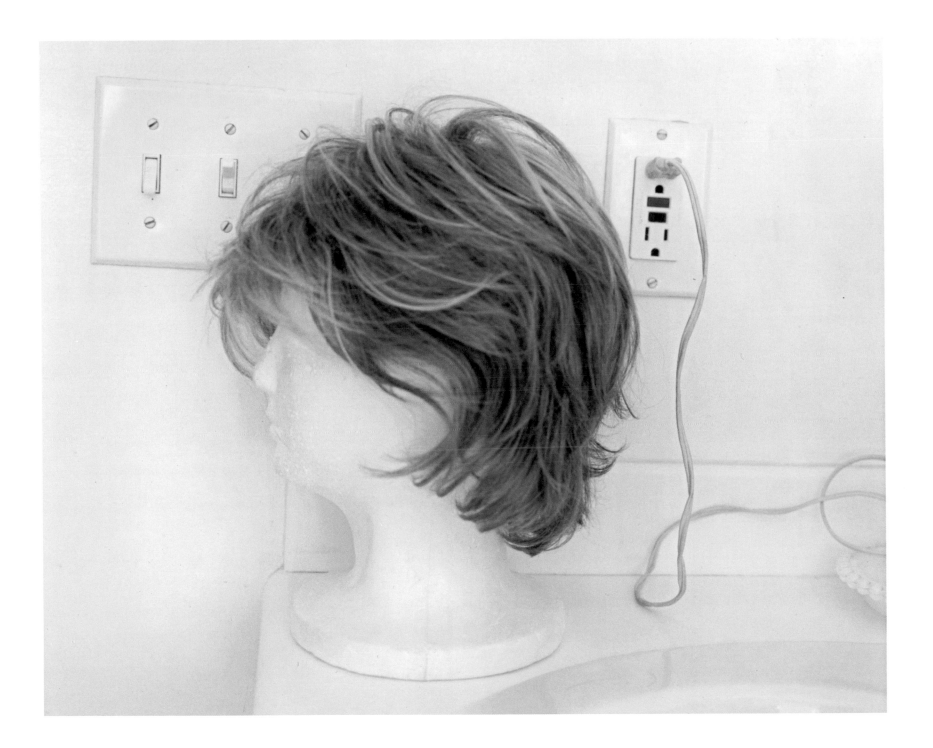

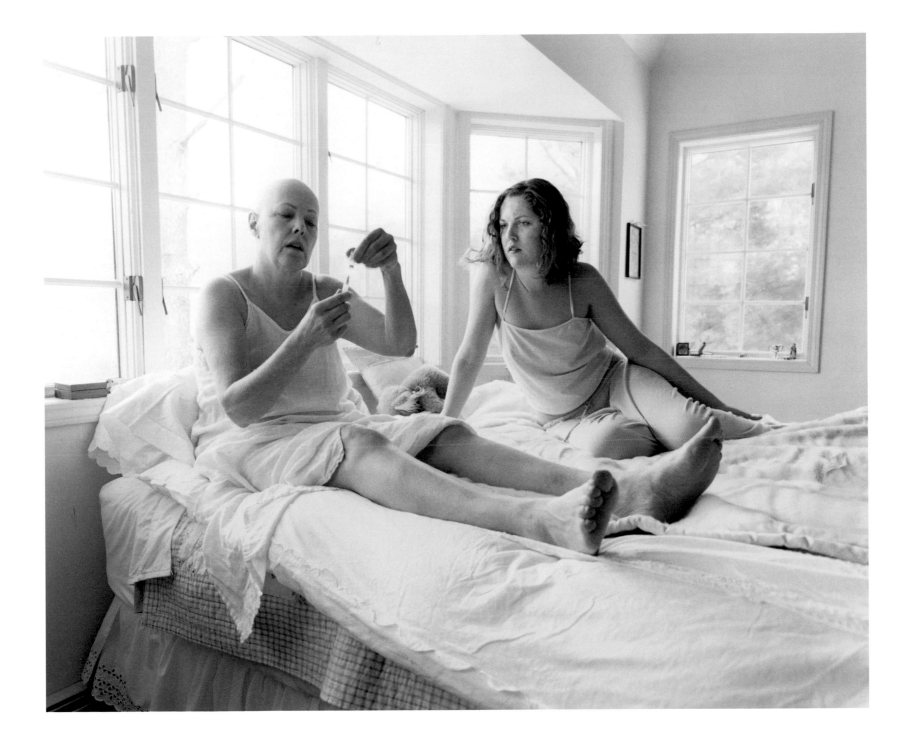

Monday, 10 March 2003

The birthday was wonderful. To live in my memory of all those weird, emotional, happy, strange times that have happened to me in the new life.

In the afternoon, while Annabel did the tables, I napped then dressed in my blue fish outfit. Black velvet with see-through skirt. My shaved head still feeling awkward. Popped on the "Raquel" wig, did makeup and felt a lot better. Fires lit, candles burning. Niva came to get dinner going—all I had to do was revel in being in my home with my loves. Tash, Liam and the boys came, then Jeff and David, Ben and the babes. Everyone got along.

Delish food. Artichoke dip-shrimp wrapped in prosciutto with arugula. Rack of lamb, roasty pots, carrots, Caesar salad and the most beautiful, made-by-Niva chocolate cake. Beautifully decorated.

Danny asked how old I was. I said "Guess." He said, "Ninety?" Then Micheál guessed seventy-eight!! I love these kids.

Yesterday, Sunday—The second gloriously sunny day in a row. Then I went to church. Once again Pastor Melinda somehow managed to come up with the sermon that I most needed to hear. About holding anger towards someone. About forgiving. Forgetting. I really like her and really like this church. It's a wonderful haven for me. I don't know whether I've found God and Jesus yet. But the comfort of shared prayer and company and singing and praying and focusing is healing and nourishing.

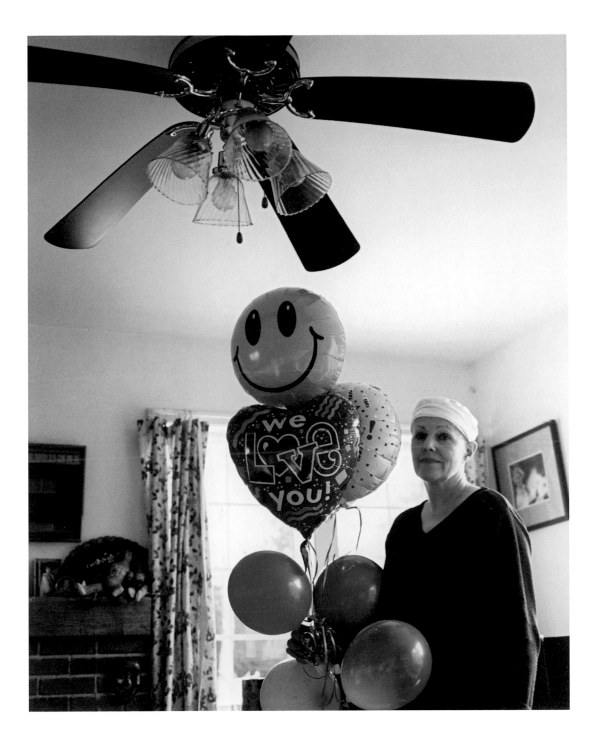

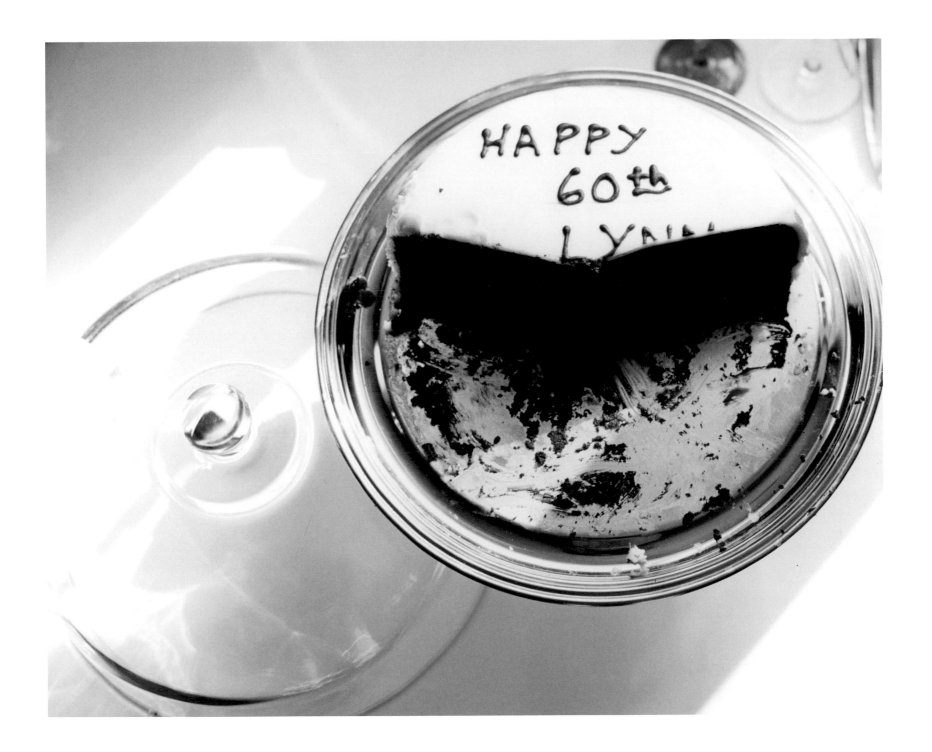

Friday, 14 March 2003

Vanessa and Mum come tomorrow! Oh how I pray that Mum does OK on the trip.

Saturday, 15 March 2003

The day my Mummy and Vanessa fly here to America. Had a not too bad sleep aided by some Ambian. Couldn't bear the thought of another wide awake 4 am! So at least I made it from 11:30 pm to 5:30 am—six hours. Had a big nap yesterday afternoon from which I had to force myself to wake. Getting excited about going home today. Even though the city is home more and more! Particularly as I add nicer touches to it. Still "Illyria" is it. With my kitties and wild turkeys and the mountain.

Sunday, 16 March 2003

The birds woke me. The birds are back. Spring must be coming.

And yesterday Mum and Vanessa arrived! Over to Tasha's and there, in the beautiful guest house was darling Mum. She held out her hands and her mouth was open in an "Oh" and her eyes wide—as I hugged and kissed her I cried, and when I pulled away to look at her, she was teary, too.

She had loved the flight; apparently British Airways were very solicitous. She kept holding my hand and saying, "I'm in b liss!" Darling Vanessa so sweet.

Today is supposed to be warm warm warm. The mountain is already bathed in sunshine and when I got up it was getting light even though it was only 5:30ish. The snow will melt. Spring will be here. In three weeks the clocks go forward. I've just checked my calendar, and I found this house on March 12th last year!

Saturday, 22 March 2003

Exhausting week. Or I am exhausted. The war began! I did my concert, chemo, dress rehearsal of Miss Fozzard. I'm beat.

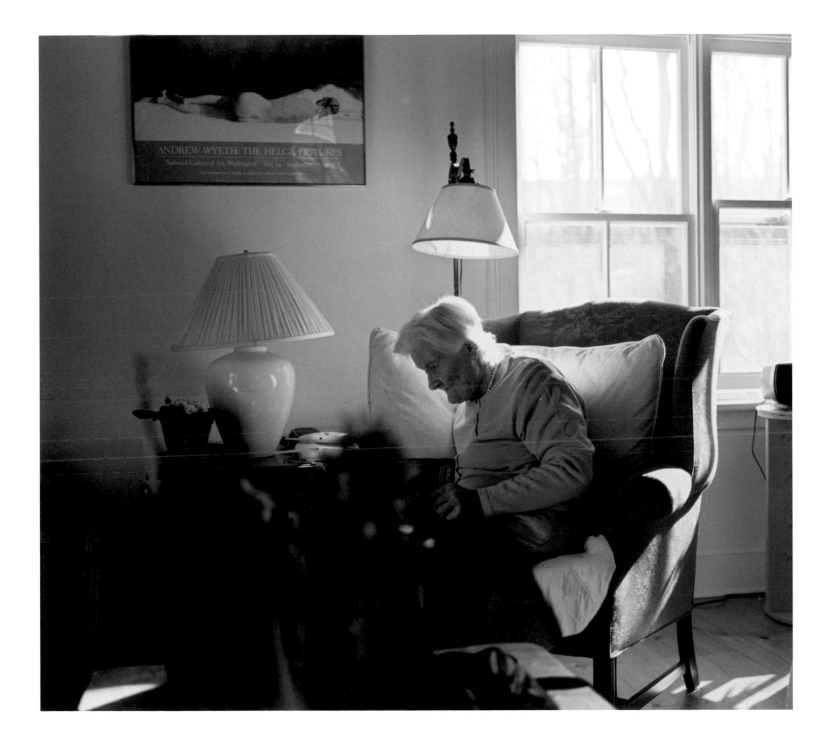

Sunday, 23 March 2003

Just one day at a time. That's the way I can handle this – Spring – though a little chill this morning. So fire is lit and tea under way. Playing the fabulous "iPod" mellow selections that Tash gave me for my birthday. Yesterday lots of rest. Friday night slept nine hours (minus drugs)—last night eight.

Tuesday, 25 March 2003

I need to get my piles and papers and records under control. Because having cancer and surgery and treatment seems to leave one out of control. So I have this need to order and control what is controllable around me.

Friday morning, 28 March 2003

The fire is crackling—sun is out. Buds on the trees. Timmy Williams the farmer has brought his cows and calves back. So the Saddle Ridge fields are occupied again.

It's all about order, I've decided. The pleasure I get and the sense of my life in place, amidst the things that I can't control. Like finding a big lump in my otherwise healthy body.

As I do things like fold my napkins into my linen closet. Or leaving clean clothes in my closet. Logs stacked. Dishes clean. Garbage out. Cats fed. Their hallway neat. It all gives me the warmest satisfaction.

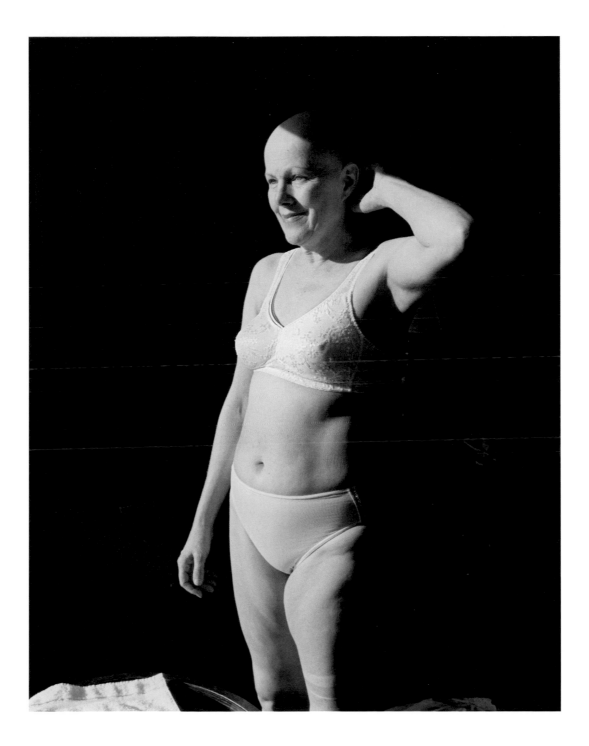

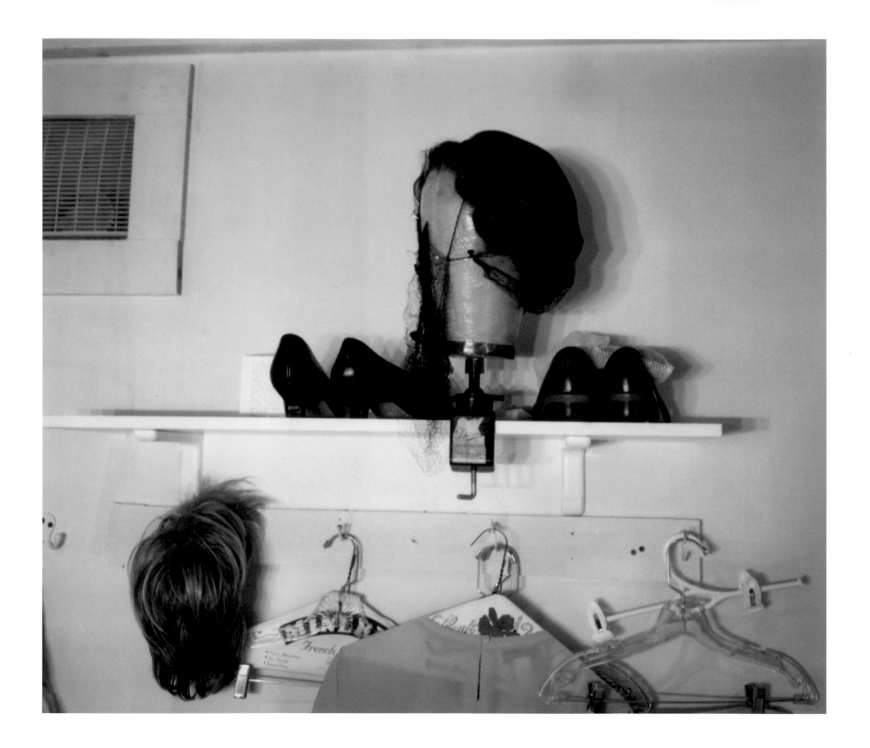

Tuesday, 1 April 2003 Illyria
Birds singing—maybe turkeys talking too. Last A & C chemo yesterday which means I have my sleeping trouble for the four days. But then it will be done. Came here yesterday. The chill of winter won't quite lose its grip. It snowed Sunday evening and didn't really settle but it has been back into winter coats and boots!

Sunday mat I felt on top of Miss Fozzard. A relief to end the week that way.

I've been feeling very matter-of-fact about my health stuff. In the routine, not scared of it—feeling good. The weak legs are probably the red cells which are a little anemic.

Friday, 4 April 2003
I'm in Hartford having early coffee. A very successful concert last night with Chamber Plus. I enjoyed it. Looked glam and felt relaxed and on top of things. Felt pretty murky as I drove. Alert, OK to drive, quite ready, but that strange murky head feeling that seems to accompany the anti-nausea drugs. Anyway, last night I took the last of them because when I start Taxol I don't have to.

Noticed that as I dried off from my shower at the Hilton little bits of stubble from my head came off on my towel. Pubic hair very sparse. Eyelashes a bit diminished. Eyebrows pretty good.

Sunday, 6 April 2003
Its opening night but also the end of a big challenging week. So I'm exhausted and going to spend the rest of the afternoon in bed.

Hartford went fine but it all takes its toll, and I just do get a bit wonky.

Tuesday morning, 8 April 2003 Early early candles, fire, tea, Illyria
Saw darling Mum yesterday. At first, for an instant she didn't know it was me. Then she said, "It's my Lynn!" I sat opposite her and we had tea and she dozed. But at one point, I put my hand on her knee, my right hand, and she began stroking my arm. Pushing my sleeve up. Sort of massaging it all the way up very gently. The snow began to fall and I headed home.

Sunday, 13 April 2003 Illyria
I woke early. The moon was high and huge. Dozing on and off, each time I raised my eye mask it had moved nearer the mountain, until finally it disappeared.

Saturday, 19 April 2003
Where did the week go? Well part of it went just keeping going. Not stopping to take in how tired I was getting until at last, back at Angel Vista on Thurs night I could relax. I was done in, plus, I had a little bit of a fever. That scared me. Visions of it mounting, hooked up to machines in a hospital. Scary.

Got Ben to come over with a mercury thermometer. It never quite made one hundred and by morning it was gone. But I was just whacked out. Lit fires, rested, napped, saw Mum, napped some more. The "big" long chemo, Taxol on Monday followed by D.C. and Larry King, sure was a huge mad day. But what can you do? If you want to live, you live flat out, no making excuses.

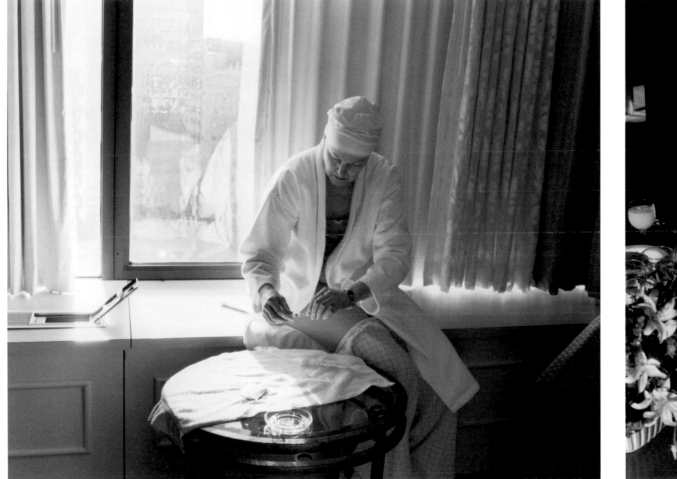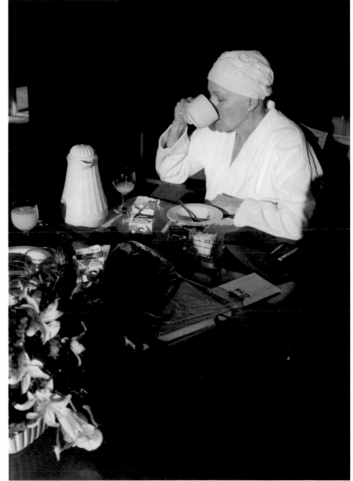

Tuesday, 22 April 2003
At Willowglen with Mum. She looks very wacky today but is always glad to see me. As I am her. It is very moving. We sang to "Get me to the church on Time" because when I arrived "My Fair Lady" was on.

I've been so tired on and off. It hits me like a ton of bricks sometimes. Other times I'm OK. Today I had a lovely time with the little sweeties Patil and Kyle. Niva and Patil were making chocolate cookies. Patil calls them, "Wee wah tooties!" So cute.

Monday, 28 April 2003
Drip went well. I went seriously wobbly before that as Dr. Hudis explained why I was for the next three to four years at high risk for a return elsewhere in my body. I somewhat fell apart down in chemo land. I called my sis—she got in a taxi and came right over. Vanessa and I got to talk pre the Benadryl phase and then the nurse Maureen came in and made me feel better. She said she has patients with no lymph node involvement who should never have a return and get one. And patients like me who are at risk who never do. She said we don't know. With cancer or without. None of us know. You just have to live your life.

Tuesday, 29 April 2003
Woke early, early—got up 3 am, thinking about Kelly and lo and behold, as I drank tea and candles burned a call—Jude Porter is here!

Wednesday, 30 April 2003
He weighed in at ten lbs! Oh my god my poor Kelly. And that he didn't breathe and had no heartbeat but then he did. Oh my god. Please keep him safe. Keep him safe.

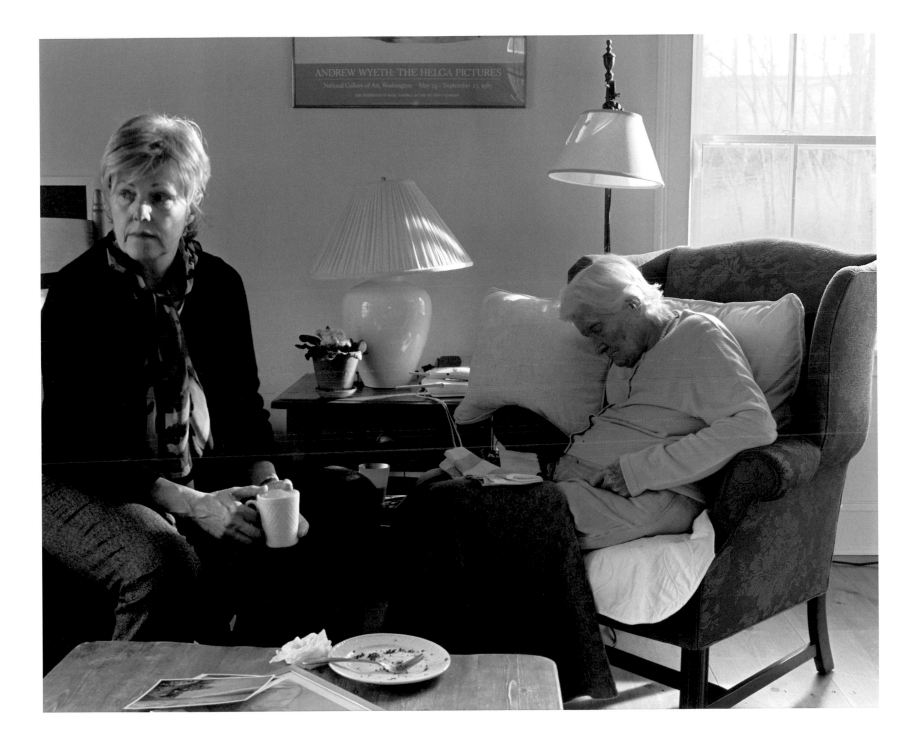

Friday, 2 May 2003

Waiting—midway between Lynn and Miss Fozzard. Still can't quite come to terms with me and cancer. How? Where is it? Is it gone? Is it hiding? I'm not ready to go. I've too much I want to do. Does everyone in my situation feel that?

I'm longing to feel pretty again. To lose a little of my extra weight. About seven pounds. But sometimes the one thing I can feel secure about and sure of is that a meal or a snack will make me feel better. Feel whole. Filling the empty strange place inside me.

I want my hair to come back. No sign so far. I think when I've got hair my missing boob won't seem so much. It's the double whammy that hits me when I see myself in the mirror.

Sunday, 11 May 2003 Illyria Mother's Day

Yesterday I went online to dog adoption places. I'm going to see a doggie tomorrow. I feel I need that healing presence. A doggie who needs a walk to get me out and literally out of myself.

Sunday, 11 May 2003

Chemo #7 tomorrow. I'm getting there. Feels like plowing a field. Just point the horse straight and keep on. Don't look too far to left or right or the line will be crooked. But what I do look at is the wonder of Spring / Summer that is upon us.

No hair still. I'm searching for signs with my magnifying mirror. I'm hoping it will surprise me just like the trees and flowering groundcover here at my house.

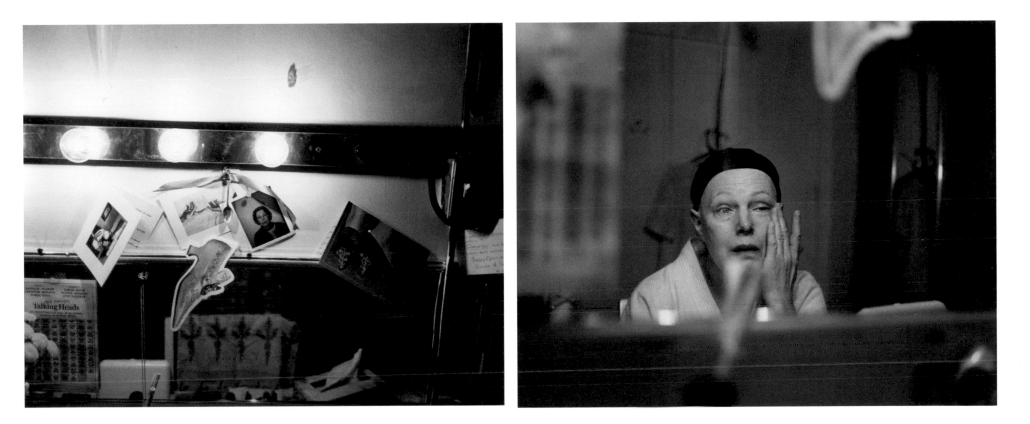

Monday, 12 May 2003

I think my Mummy is fading away. Jocelyn Herbert just died. I think my Mummy is dying, too. Annabel and I were with her yesterday. So much frailer. Not with us really. Had my third Taxol—only one to go.

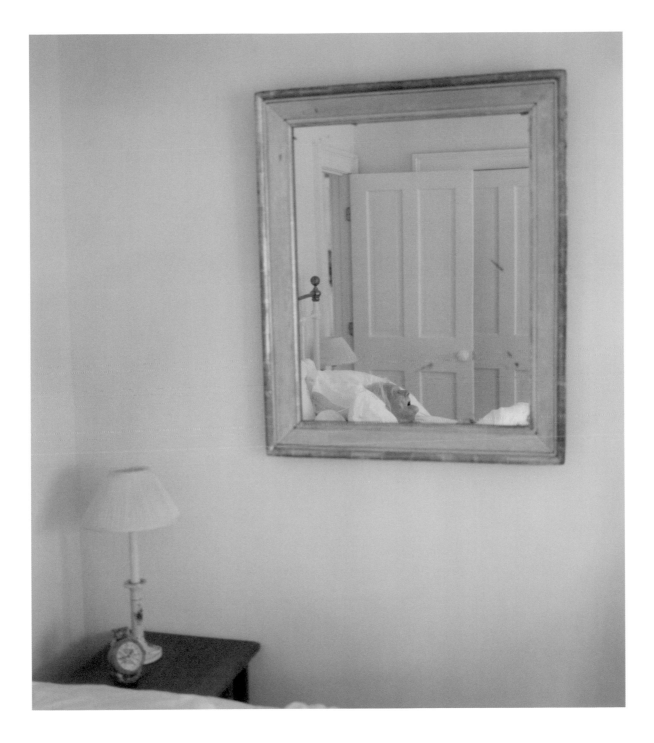

Friday, 16 May 2003
Last night I adopted Viola and drove her to Illyria. She is so sweet and very good indeed. Slept happily in the car the whole way in the passenger seat. She slept without complaint in the kitchen in her crate. I woke too early, probably wanting to be sure she was OK.

I'm feeling very out of it this morning. My feet bad. Worst they have been. Thank God, only one more Taxol. The numbness and tingling is uncomfortable.

Saturday, 17 May 2003 Illyria
What a difference a day makes. Yesterday I felt I was moving under water—the usual end of the first week following chemo. I've had this more or less each time. Even the numb tingly feet were really bad yesterday. But today following a really lovely dinner party I feel good. Bright.

Took Viola to a dog park. She loved it. It's a whole New York culture. Chatted to a few people. I've had more exercise these two days than I've had since surgery. This will be so good for me.

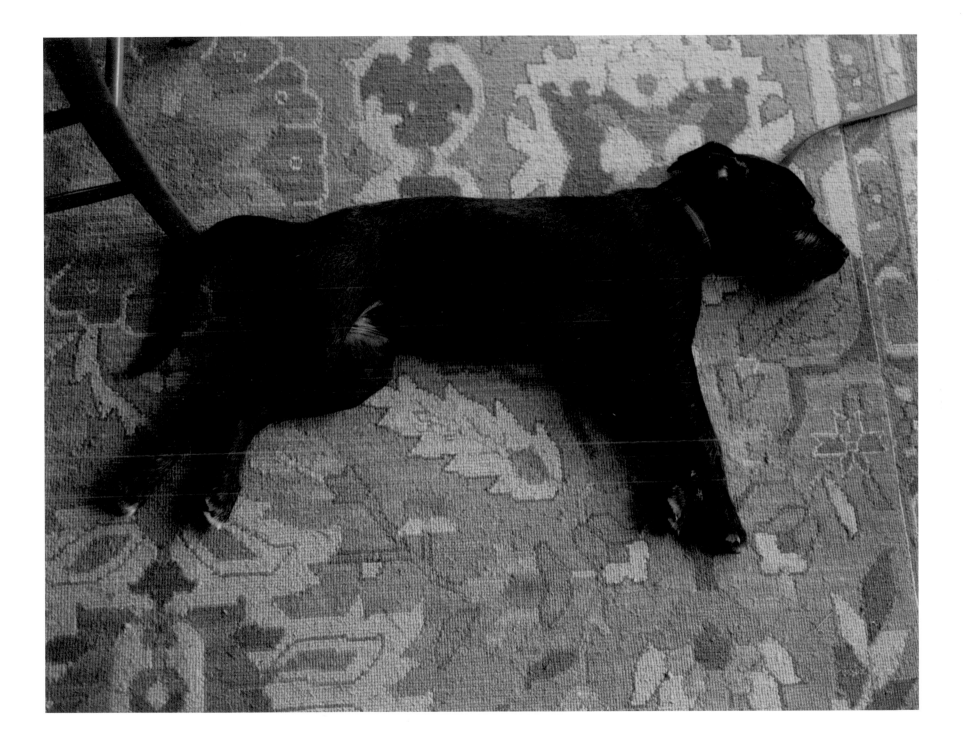

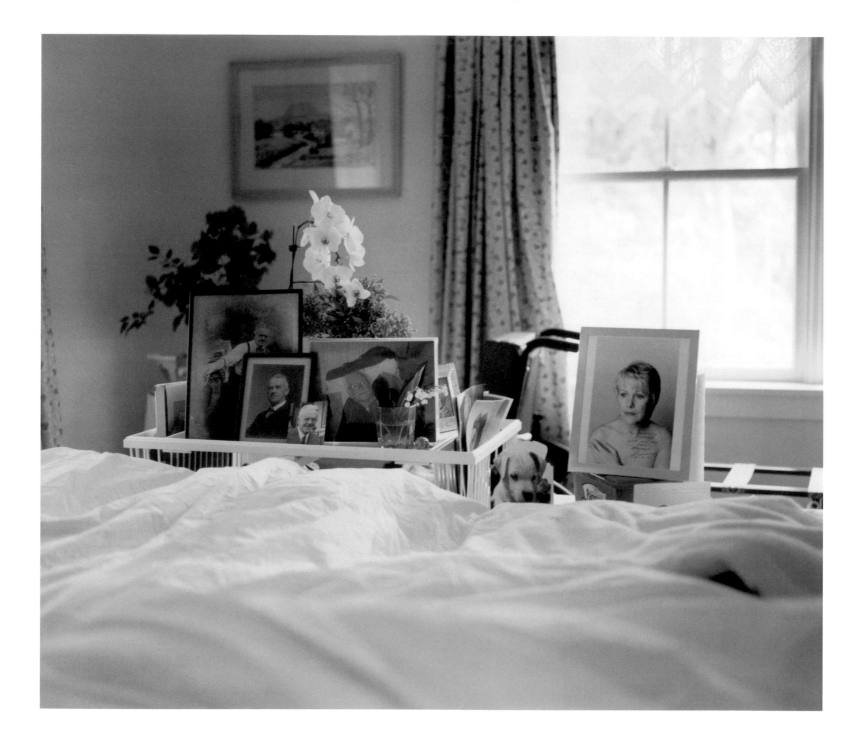

Tuesday, 20 May 2003
At Mum's bedside as she restlessly tosses her head, raises her right arm up and down and occasionally scratches her head.

On Monday afternoon, word that Mum had had another stroke and wasn't coming round. Many phone calls with Vanessa and she headed to the country. As it was happening, in fact, Corin, Vanessa and I were lunching at Gabriel's on Sixtieth Street.

7:35 pm
Rachel's jaw is tightly closed. Making her look very determined. Several times she has pulled really strongly on my hand and lifted herself halfway to sitting.

9:15 pm
She's now quite peaceful. I've been playing her the Vaughn Williams "Greensleeves" CD. When "Greensleeves" first began playing I said, "Do you remember this?" And she nodded and smiled. Nodded twice. I conducted for her and held her hand through "Lark Ascending." She seemed to hear that. This is a privilege. I don't feel like talking to anyone right now except my Vanessa and Corin and Benjy and Annabel.

I'm full of tears and yet happiness that I get to experience this with Mum. Vanessa and Corin and I went and looked at the cemetery near here. It is beautiful. A field overlooking more fields. They feel she should be buried where I can visit her. I think if we do that I will want to be buried by her when the time comes.

Sunday, 25 May 2003, 3:20 am-ish
How to get it all down in order. How to surface through the weight of the tears still sitting in my eyes, behind my eyes.

After my show Friday night and hellos to friends, I had some wine and uncharacteristically, turned all my phones off.

When I woke yesterday morning it was with this feeling that the phone had been going and that it was Mum.
Vanessa's message. "Our darling has gone." 1:20am Saturday May 24th.

We plan for the funeral to be Thursday at 11. The day after her birthday. She would have been ninety-three.

I said to Vanessa yesterday, "I'm so glad she never knew about me. Never knew about cancer. She would stroke my hair (wig) and say how pretty it was."

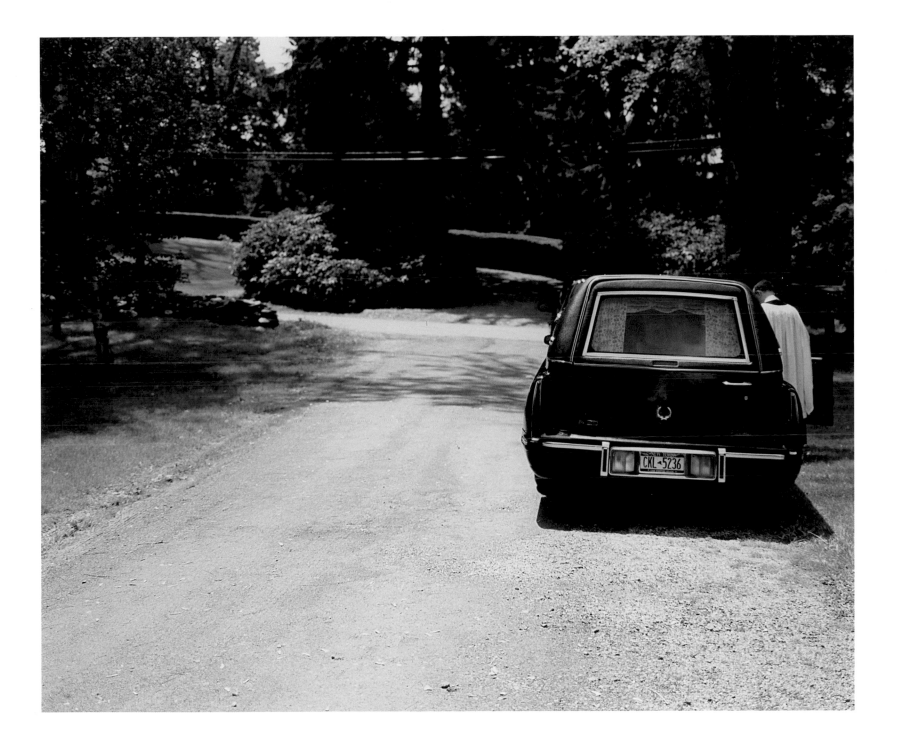

Sunday, 1 June 2003 New York
Rain, rain. I'm feeling better today but apart from Mum's death I have been low this week. Fingers and toes and feet numb and tingly from the Taxol. Ankles a little puffy. Tattoos looking like blackheads—six of them from my radiation simulation. Lots of squeezing aches in my scar tissue. The dead bits making me feel a little plain. Almost dirty.

But today better. Always is one week on from chemo. And I've had my final one now. Still injecting GCSF.

Monday, 2 June 2003
Woke early with Mum sitting right there in my head and heart. So got up and took Viola out. Now tea, candles and a long talk with Carry.

Monday, 9 June 2003
Haven't been able to write. Had a little bit of a fever. Did the show. Saturday morning temp 100.4. I was so scared. Called the hospital and went in. They rehydrated me and did lots of tests and then let me go. I felt so deathly. Couldn't get off the sofa. Just wanted to lay down.

So I managed the matinee and went to *Nine: The Musical* with Susan. By Sunday morning, thank God I felt better.

Wednesday, 11 June 2003
Oh fuck fuck fuck! Back in the hospital. Dr. Hudis called to say the bug I picked up from whatever I ate is now growing in my blood. Fuck piss!
I feel so well—Damn it. I've told them I have to do my matinee and if necessary I'll come back. I think they will let me. Cross fingers, cross fingers.

Tuesday, 17 June 2003

Vanessa sleeps downstairs and I look back at yesterday and last night as one of the very happiest ever. We've talked and gossiped and recollected and it's been total heaven. Health-wise, I feel so good and don't look forward to the possible side effects of radiation (i.e. feeling tired again when I have begun to feel so much myself).

Life is good. Please dear God, dear life, I'm being demanding, but let me please have more. Let me not have to cut it short. More time please, to love, to learn, to act, to write, to enjoy my family. Please.

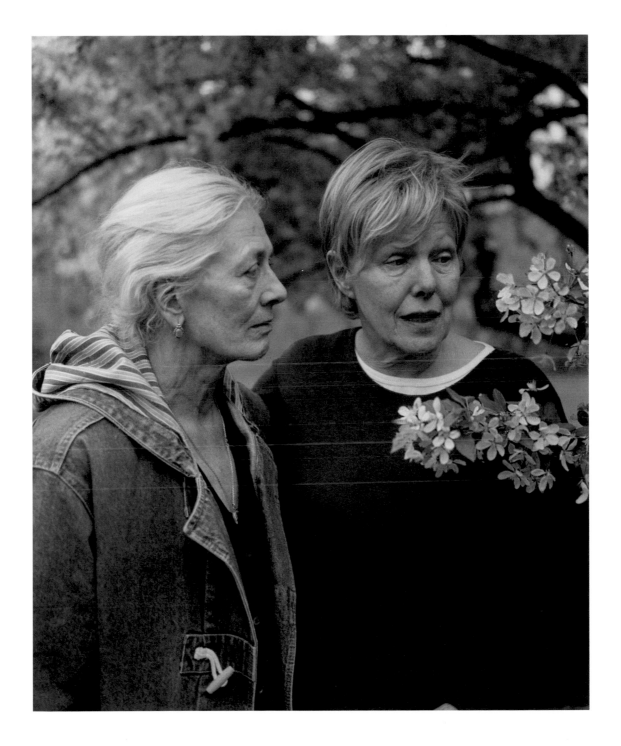

Wednesday, 18 June 2003
So here is what happened. Came with Annabel yesterday for what was going to be the dry run radiation but they decided to go ahead and treat me anyway. First though, I had to lay still for over an hour. In my cast. At first it's fine but then the fingers of my right hand go dead. Then Annabel rubs it. Much better but now my arm, then neck, then head, turned to one side, begin to really really hurt. Mustn't move. The technicians purposefully stride in and out. Putting in film, moving the big machine. Each time they leave, the radioactive proof door closes automatically. I'm alone in there with a loud machine. They can see me on a monitor, but I am alone. Annabel of course has to also leave the room. Whoever designed the treatment rooms has thoughtfully painted flowers on the ceiling. It's all very high tech, but they have definitely tried their best to make it patient-friendly. And the people are really nice.

Afterwards, we taxied over to an audition for a voice over. I felt it went really well. Then Tea and Sympathy for a cream tea. Scones, cream, jam, tea. Yum. Then home to total trash *America's Next Top Model*. So stupid and fun. A little Shiraz with a gorgeous salad. And then to bed. My angel stayed over.

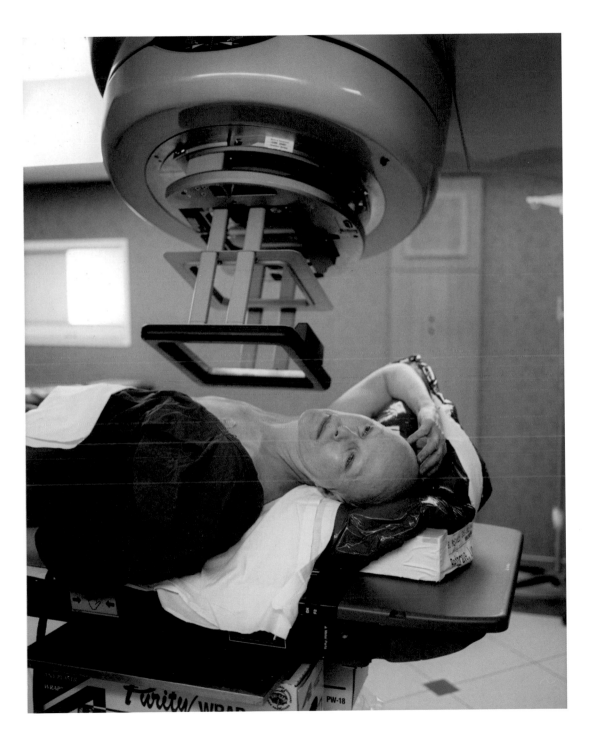

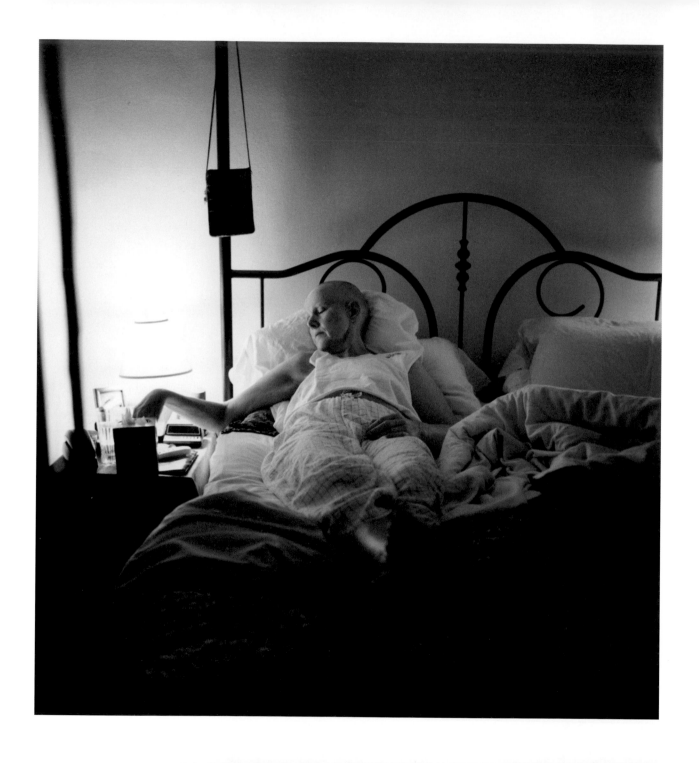

Thursday, 19 June 2003
And it just keeps raining. Rain, rain, rain. Non-stop.

At the hospital—radiation #3. That means maybe only twenty-two more!

What I've noticed: my legs are stronger. My feet don't hurt so much. The weird breakdown of the calluses seems to have gone. My nails on my hands are pulling down, some of them. Both thumbs, both forefingers, right third finger. On my right foot, the nail I stubbed some weeks ago dropped off. Underneath the new nail looks thin and damaged.

My Annabel stayed over Tuesday evening and we did some tidying and sorting. I've started on my letter writing. Condolences, etc. But…there are just not enough hours in the day. Each day I plan to get so much done, but the parameters of the show and now this daily hospital routine is leaving me without a lot of time. Or sometimes not enough energy. Though my life with Viola has definitely made me much fitter. I think the combination of the chemo leaving my body and the daily walks. Twice as much exercise as during the chemo days. I've lost about five pounds—Could do with losing another five.

What will I do when my Vanessa leaves town?

At the theatre
What I've also noticed: that my face was puffy before and my ankles all swelled up and now they're not! And my face is looking like me again.

Got a little low today. Went into Barnes and Noble and made the mistake of glancing at a couple of cancer books. Got scared. What if I die?

Saturday, 21 June 2003 On the F Train going to my matinee

There's no doubt that I have my days when I quite dreadfully fear death. *Or it's fear of chemo again.* Of losing my hair again. Of my face puffy again. Of the brave face in the mirror.

Monday, 23 June 2003

I think I will shave my legs today. I have long hairs! Very fine and white, but hairs! It will actually feel good to do it. A return to my old self. But will the old one ever be right back. I don't see how it can—or rather she can. The me I was when I bought my house. The carefree me. The happy happy me. I can be happy again, indeed I have been and often am, but I will always have the threat hanging there.

Saturday, 28 June 2003 Illyria

The sweltering heat of the last few days has cooled off and I have had two very happy days—well, actually it's still only 9 am but it feels like two days.

Suddenly I feel less fearful. What will be will be. The fear of early death seems lifted. I feel good. I feel happy. My nine radiations are beginning to look a little red—but really not all that bad. It's easy to close my eyes under the machines and go somewhere else inside myself. I'm not on the table. I'm not being nuked, I'm off with my loved ones. My ability to do this has grown during this funny old journey. By the side of the stage each performance of *Talking Heads*, my ghosts visit. Dad, Mum, Nanny, Vanessa, Corin, Robert Stephens, Noel Coward. They send me out there calm and ready.

Tuesday, 1 July 2003

A thought while on the radiation table this morning. Having cancer treatment is LIFE AFFIRMING. I am now truly living in the moment. Wishing nothing away in terms of time. Not leaping forward, just living and noticing everything.

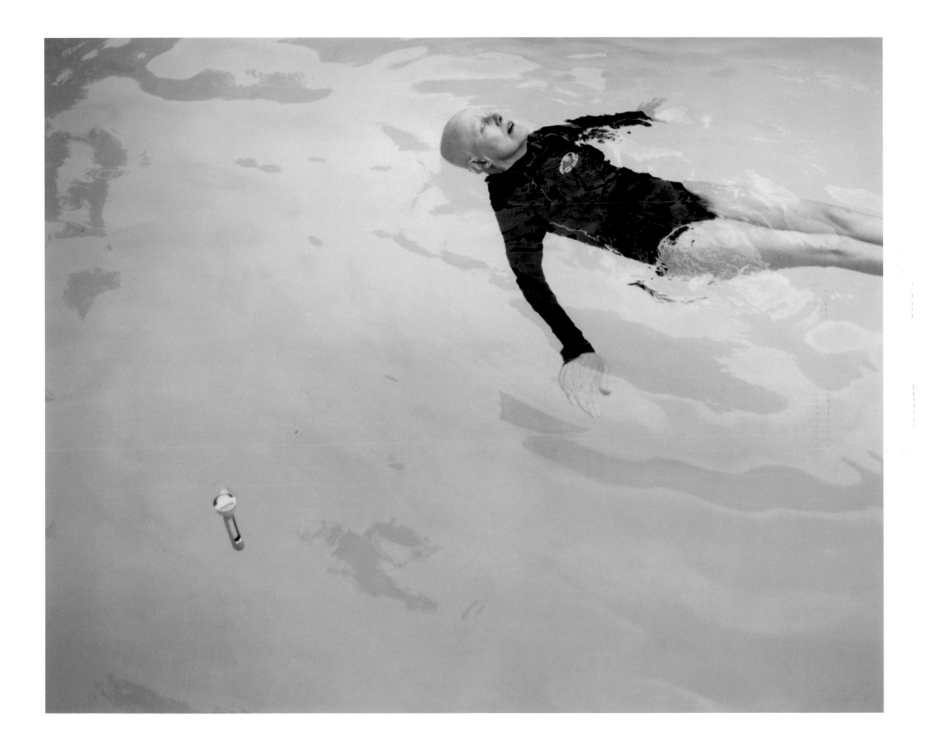

Thursday, 3 July 2003

Radiation #13—More than halfway. My hair is now visible—I've lost eight pounds. My clothes fit. I feel the most like the "pre-cancer me" than I've felt in all these long months. Six and a half months ago I was diagnosed. Coming to the hospital each day hasn't been so bad. Gives a frame, a structure, a sense of order. Of progress. Of healing. I've met lovely people.

Monday 7 July 2003

Today I had radiation #14. Eleven more to go. And today is the first day it's really hurt. The skin is feeling burnt. The itchy patch is much worse so I've been given new ointments. One is an antibiotic and one is cortisone.

They are greasy, and I've had to put a little camisole under my bra so that my costume won't get messy. My right eye has no eyelashes at all. My left has two or three. And my eyebrows are almost totally gone. My toenails look strange and have lifted slightly, fingernails have lifted back too. Tonight is the first time in a while I've felt like crying. I've a bit of a head cold so I think it's made me a touch wobbly. Everything is a bit of an effort.

Saturday, 12 July 2003 Illyria
The countdown is underway for the hospital. I'm so nearly there. Just seven more times on the machine. This coming week and then the Monday and Tuesday of shows and holiday—Vacation at home. Time to fix my house. Go to flea markets, play with the kids, go to the lake. Have dinner parties perhaps. Just relax. Just live.

At the theatre
My hair is really growing back—it's not just white, the browny salt and pepper is coming too. It feels so great to touch it. To run my hands over it. To feel the swirls, the way it grows—My brows seem to be gone gone gone but I can see a faint fuzz where they used to be.

Friday, 18 July 2003 On subway
Countdown continues towards, as Jeff said this morning, "Getting my life back." After this morning just two left.

Thursday, 24 July 2003
For the first time in weeks almost luxuriated in the pleasure of having the morning stretch in front of me. No hospital. No rushing for the subway at 9:30 am.

And my hair. It's so very soft and it's pretty and I think when my holiday is over I shall take off my wig for good. I can't stop playing with it. Sitting in the dressing room stroking it. Examining it in my magnifying mirror.

Wednesday, 6 August 2003
I'm watching *Life Stories*—all about Lance Armstrong, the cyclist who overcame cancer. His wife talked about his training while on chemo. That it proved to him he wasn't sick. I guess that's what working through my chemo has done for me. It tells me I'm OK.

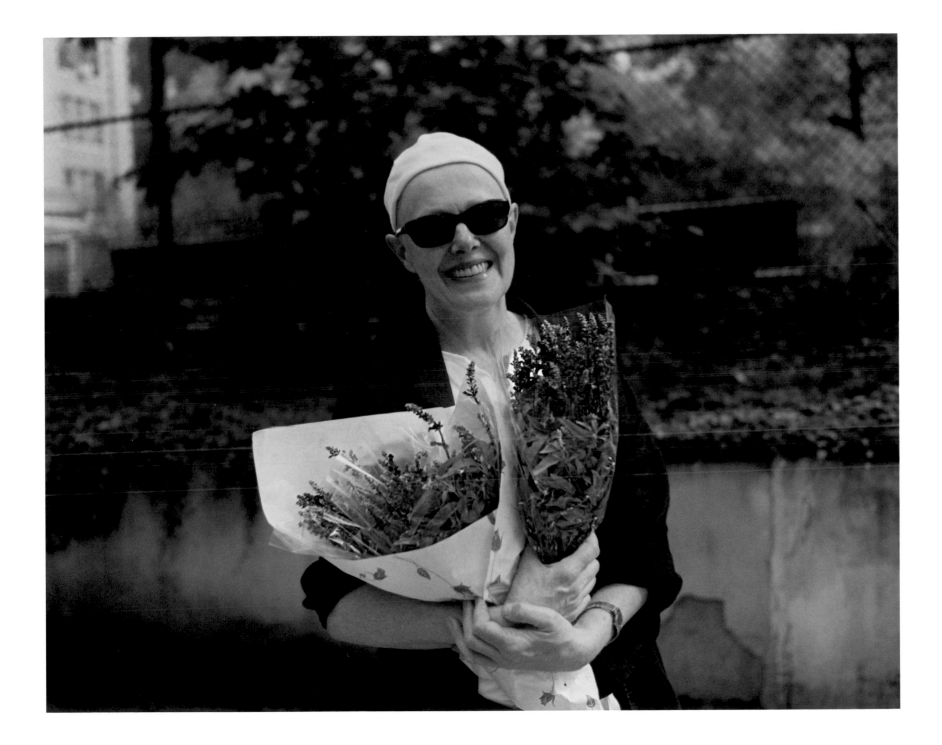

Saturday, 9 August 2003 My Vacation
Vanessa is going to commute next week and come and stay with me a couple of nights...

It's humid again today—there was more rain in the night, but yesterday was a golden afternoon.

I think I'm the nearest I've ever been in my life to feeling complete. Cancer has given me a certain freedom. Odd but true.

Monday, 11 August 2003
So it was a perfect day—Up early to get Annabel to the train for work. Back home—light by now. Sort through closet and underwear. Discard for thrift shop underwire bras—bras for two boobs. "What are you going to do?" asked Joely about reconstruction. I said I wasn't going to although I still had the option. But in truth I think it's about accepting in myself the changes that have taken place in my life. Battle scars? I had this vision of altering oneself—cutting oneself, not worthy, not beautiful unless…and I'm thinking, as I sit on my porch with candles and wine—no. My lesson to learn through my long-ago eating disorder, through my cancer, my acting, my life, my loss of youth, my lesson is that the essential core of me is right here—unadorned, single breasted—that's a way to look at it.

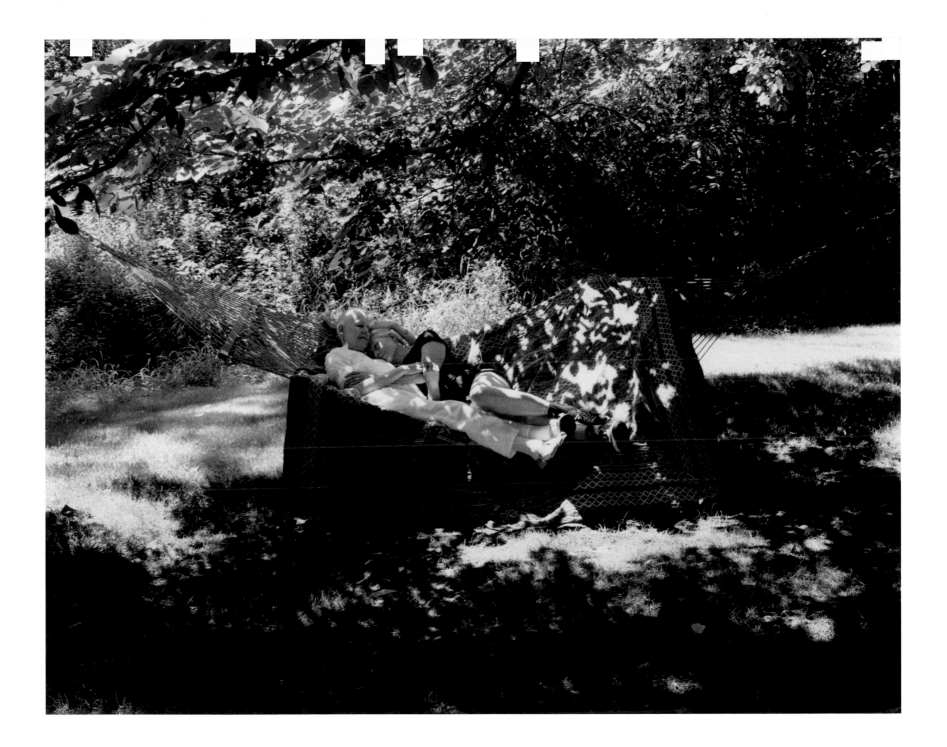

Thursday, 21 August 2003
My hair is cascading in! When I put my wig on there's a hairline to contend with—My show wig, I mean of course, because I'm not wearing my Raquel wig now.

Wednesday, 27 August 2003
It's almost surreal now. A dream of something that happened to me. That strange druggy feeling during the chemo. The sadness as I'd look in the mirror at my bald head, my slightly misshapen face—The days when I couldn't believe really that I'd be myself again. And all along *Talking Heads* to come downtown for. I've just finished my makeup and hair and it's Miss Fozzard looking back at me from the mirror.

Tuesday, 2 September 2003
One of the lovely mornings alone but for Viola, when I feel so content, so peaceful, so utterly "present." Sunday was Vanessa's final show and Annabel and I went and oh God, it was so beautiful. After a brief visit to the party, Vanessa, Annabel and I went to Café Lux. Her favorite. When we dropped her off and she waved goodbye I managed to wave without crying, but then, as we drove away, Annabel and I sobbed. As I write this I feel teary that she will not be in reach anymore.

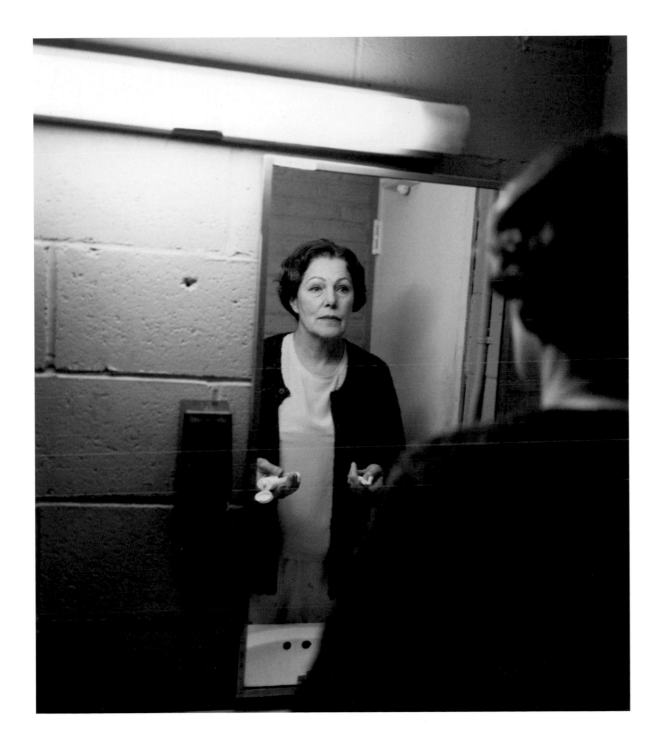

Wednesday, 3 September 2003
Back at the hospital for my routine gyno check. Coming in the elevator people looked very sick. Really fragile—weary—scared. Made me feel a little scared too. To be back. These few weeks with no treatment have been heaven. As though I maybe dreamed all this. But of course I didn't. It's not a dream and all around me people seem to have it.

Tuesday, 14 October 2003
Second week of *The Exonerated* in Fort Lauderdale.

And I haven't been writing. I was I think to begin with, a little lonely, a little depressed, intimidated somewhat by the alien feeling of Florida. But something led me to church on Sunday. And something must have called me to pick the particular church that I chose. St. Mark's Episcopal Church. I found myself as so often is the case quite emotional during the service and particularly the communion. As I walked out the female priest shook my hand. She asked me if there was anything she could help me with. I told her about having cancer and being scared. She said, would I like to meet for a talk and I said yes. Today I phoned her and went to see her. It was a remarkable meeting. I told her my story and that what I wanted was to put fear in perspective and not have it living with me all the time. She said when she gave me the chalice on Sunday, it seemed that something remarkable was going on. That I was very pale—She talked about my being able to be a minister for others and prayed with me and for me and anointed me with healing oil. I left feeling calmer—almost like the tension was drained out of me. How strange and wondrous. That in a place where I feel insecure and fearful and constantly in some sort of touch with my mortality, I should be led to a wonderful, healing, compassionate woman.

Wednesday, 12 November 2003
Had my four-month check up yesterday and all is well. My face feels relaxed and peaceful. My scar squeezes, but that tells me I am alive.

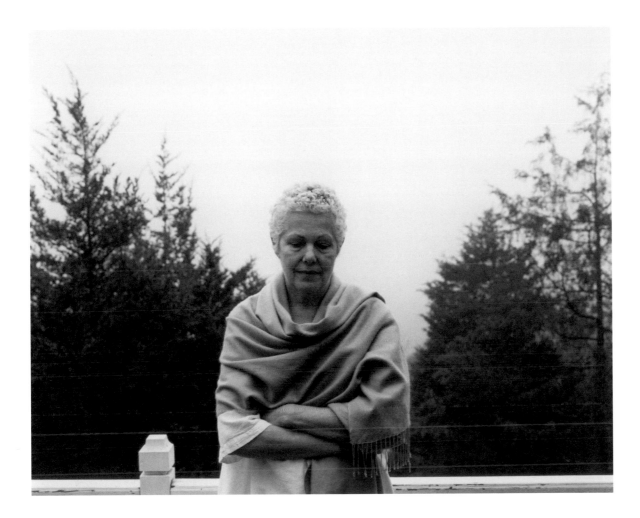

Friday, 12 December 2003 One Year Survivor
One year ago today, I found my lump. One full year of fear and joy and courage and unfettered love of (or do I also mean for) MY HEAVEN.

Friday, 26 December 2003
I have found a quieter place within myself—the quiet pleasures of the morning with my tea, my dog, my candles—the quiet acceptance perhaps of my new self. The surgery and treatment did cut and burn away the remnants of the impatient, insecure me—The me who would find fault with work situations, wanting to put the world right from my point of view.

The year is winding to a close—my big eye-opening year.

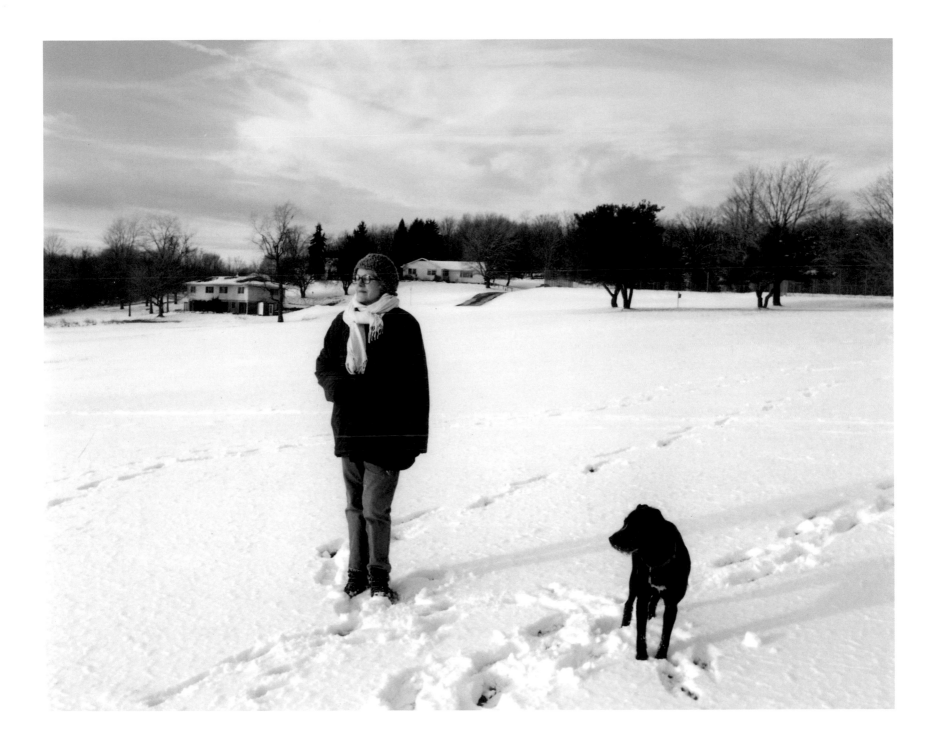

WEBSITES

National Breast Cancer Awareness Month
www.nbcam.org
Donning pink ribbons and taking to the streets every October, NBCAM is devoted to building awareness about breast cancer. Their website includes an extensive list of cancer resources and information about how to become involved in the fight against breast cancer.

The Cancer Research and Prevention Foundation
www.preventcancer.org
The Cancer Research and Prevention Foundation is a non-profit whose mission is the prevention and early detection of cancer through scientific research and education.

Association of Online Cancer Resources
www.acor.org
Association of Cancer Online Resources provides free online information and a referral base for almost 100 electronic mailing lists and websites specifically designed to serve as online support groups for anyone who may be effected by cancer.

Cancer News
www.cancernews.com
This website provides cancer patients, survivors and their families with up-to-date medical information on the treatment, diagnosis, and prevention of all types of cancer, as well as a list of online cancer support groups.

ORGANIZATIONS

Avon Foundation Breast Cancer Crusade
505 Eighth Avenue, Suite 1601
New York, NY 10018
Ph: (212) 244-5368
Fax: (212) 695-3081
E-mail: admin@avonbreastcare.org
www.avonbreastcare.org
The Avon Foundation is a public charity whose goal is to raise funds towards finding a cure and providing access to medical treatment, specifically for those who are medically underserved. Beneficiaries range from leading cancer centers to community-based non-profit breast health programs and extend to more than fifty countries worldwide.

American Cancer Society
Hotline: (800) ACS-2345
www.cancer.org
The ACS provides a free nationwide hotline for breast cancer information. They also offer referrals to local Reach to Recovery support groups, among others. The ACS has educational materials available for both patients and healthcare professionals.

Breakthrough Breast Cancer
Weston Housse, 3rd Floor
246 High Holborn
London
WC1V 7EX
United Kingdom
Tel: +44 (0) 207025-2400
Fax: +44 (0) 207025-2401
Hotline: 0808010-0200
www.breakthrough.org.uk
E-mail: info@breakthrough.org.uk
Breakthrough Breast Cancer is committed to raising both awareness and funds as the U.K.'s leading breast cancer charity.

Cancer BACUP
3 Bath Place
Rivington Street
London
EC2A 3JR
United Kingdom
Tel: +44 (0) 207696-9003
Hotline: +44 (0) 808800 9003 (toll free from inside the UK)
www.cancerbacup.org.uk
Cancer BACUP is Europe's leading Cancer Center and home to over 4,500 pages of information and support guides for patients and caregivers alike.

CancerCare
National Office
2757 Seventh Avenue
New York, NY 10001
Tel: (800) 813-HOPE
E-mail: info@cancercare.org
www.cancercare.org
CancerCare is a national non-profit organization whose mission is to provide free professional help to people with all types of cancer through counseling, education, information, referral, and direct financial assistance.

The Cancer Research and Prevention Foundation
1600 Duke Street, Suite 500
Alexandria, VA 22314
Tel: (703) 836-4412
Fax: (703) 836-4413
Helpline: (800) 227-2732
E-mail: info@preventcancer.org
www.preventcancer.org
Since 1985, the Cancer Research and Prevention Foundation has been fighting the war against cancer. Concentrating on early detection and prevention, the foundation is a forerunner in progressive research while maintaining an active presence in the community.

Esteé Lauder-The Breast Cancer Research Foundation
654 Madison Avenue, Suite 1209
New York, NY 10021
E-mail: bcrf@estee.com
www.bcrfcure.org
The Breast Cancer Research Foundation has raised many millions of dollars to provide funding for clinical and genetic research.

Lynne Cohen Foundation
P.O. Box 7128
Santa Monica, CA 90406-9126
Tel: (877) OVARY-11
Fax: (310) 571-9126
www.lynnecohenfoundation.org
When Lynne Cohen lost her life to ovarian cancer, her three daughters started this foundation in her memory. The Lynne Cohen Foundation supports research, hoping to improve the survival rate for women diagnosed with ovarian cancer and increase the chances of early detection.

National Alliance of Breast Cancer Organizations
9 East 37th Street, 10th Floor
New York, NY 10016
Tel: (888) 80-NABCO
Email: nabcoinfo@aol.com
www.nabco.org
NABCO is the leading non-profit resource for breast cancer information and support in the U.S. NABCO provides educational resources on their website, as well as publishing a quarterly newsletter, *NABCO News*.

The National Cancer Institute
Hotline: (800) 4-CANCER
TTY: (800) 332-8615
www.cancer.gov
Dedicated to cancer research and early prevention, the National Cancer Institute is the government's principle agency for cancer research and training. Their website contains comprehensive health information for all types of cancer.

The National Coalition for Cancer Survivorship
1010 Wayne Avenue, Suite 770
Silver Spring, MD 20910-5660
Tel: (301) 650-9127
Fax: (301) 565-9670
Helpline: (877) NCCS-YES
E-mail: info@canceradvocacy.org
www.canceradvocacy.org
In addition to raising awareness of cancer survivorship, NCSS is involved on a national level, providing public policy leadership among national cancer organizations.

Revlon Run/Walk For Women
Event Hotline: (310) 393-6344
E-mail: RRWLA@davisgrp.org
www.revlonrunwalk.com
Every year this 5K walk helps raise funds for medical research of women's cancers. Shoulder to shoulder down the streets of Los Angeles, patients, survivors, family, and friends come together to support the fight against cancer.

Salick Health Care
8201 Beverly Blvd.
Los Angeles, CA 90048
Tel: (323) 966-3400
www.salick.com
Salick Health Care focuses on cancer care, providing consulting services and managing the operation of numerous comprehensive cancer centers throughout the United States. Their goal is to help patients and their families meet the challenges of the disease.

Susan G. Komen Breast Cancer Foundation
5005 LBJ Freeway, Suite 250
Dallas, TX 75244
Tel: (972) 855-1600
Fax: (972) 855-1605
Helpline: (800) IM-AWARE
www.komen.org
Funding research, education, screening, and treatment projects, the Susan G. Komen Breast Cancer

Foundation's goal is to eradicate breast cancer. The Foundation has been active in the fight against breast cancer for over twenty years and has built up a community of local affiliates across the world.

Y-ME National Breast Cancer Organization
212 West Van Buren Street
Chicago, IL 60607-3908
Tel: (312) 986-8338
Helpline: (800) 221-2141
Spanish Language Helpline: (800) 986-9505
E-mail: cmorris@y-me.org
www.y-me.org
Y-ME offers support and information through their 24-hour a day hotline for women with breast cancer, as well as family and friends.

The YWCA EncorePlus Program
Tel: (800) 95-EPLUS
www.ywca.org
Located in participating YWCA's throughout the country, the EncorePlus Program provides early detection, low-cost mammograms, outreach, education, support and exercise services.

ANNABEL CLARK was born in Topanga Canyon, California in 1981. She moved to New York in 2000 to pursue photography and received her B.F.A. from Parsons School of Design in 2003. Her work can be seen in *The New York Times Magazine*, *The ObserverMagazine*, and *American Photography 20*. She is currently photographing adults who live with and take care of their sick or aging parents.

LYNN REDGRAVE was born in London, one of five generations of actors in the Redgrave family and the youngest child of Sir Michael Redgrave and Rachel Kempson. She is one of seven family members still acting today, including her sister Vanessa and brother Corin. She made her stage debut in 1962 in *A Midsummer Night's Dream* and went on to become a founding member of The Royal National Theatre in Britain. Her film debut came a year later in *Tom Jones* and in 1966 she received her first Oscar nomination and a Golden Globe and New York Film Critics Award for her role in *Georgy Girl*. She has since appeared in over sixty films, including *Gods and Monsters* (which won her a second Golden Globe and an Oscar nomination). Her numerous theatre credits on Broadway and the West End in London have brought her two Tony nominations, an Outer Critics Circle Award, and an Obie. She completed a national tour of *The Exonerated* in 2004. As a playwright, she is the author of *Shakespeare for My Father*, *The Mandrake Root*, and *Nightingale*. She began her first journal when she was five and has written in one ever since.

DR. BARRON LERNER is the Professor of Medicine and Public Health at Columbia University College of Physicians and Surgeons, and is author of the critically acclaimed book, *The Breast Cancer Wars*, among other publications. He lives in Westchester County, New York.

Acknowledgments

There are many people to thank for making this book possible, some for their support of my photography and this project and others for their emotional support through the ups and downs of cancer. I'd like to especially thank those who have taken on both roles.

I began photographing my mother during my last year at Parsons School of Design. The encouragement of the staff and students in the Photography Department before, during and after this project is deeply appreciated. I am especially grateful to Vince Cianni, Neil Selkirk, Penelope Umbrico, Charlie Harbutt, Brian Lav, and Alizabeth Fritz for their inspiration and honesty.

For her support of the project and for making it a part of the Health issue of *The New York Times Magazine* in April 2004, I would like to thank Kathy Ryan, also Cavan Farrell, James Ryerson, Brent Murray, and Dan Saltzein for their work on that story.

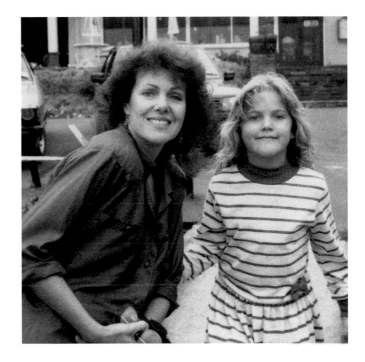

I am forever indebted to Andrea Dunlap for bringing me and my book to Umbrage Editions and to Nan Richardson for deciding to publish it. Thank you to Amy Deneson, Launa Beuhler, and the Umbrage interns who have worked on the book and to Carol Fonde, Chris Austin, Junsik Shin, and Isaac Turner for helping me with the prints and difficult negatives.

I'd like to thank Ken Regan for letting me follow him around and learn from him for seven weeks and for his continued enthusiasm for my work.

Thanks to all of the doctors, nurses and volunteers at the Memorial Sloan Kettering Breast Cancer Center and Hospital who took care of my mother and allowed me to photograph around them, especially Dr. Patrick Borgen, Dr. Cliff Hudis, Dr. Beryl McCormick, and Maureen Major.

My gratitude to Carole Shelley, Joyce Wadler, Simone Grant Timoney, and Nicole Bradin for letting me photograph them at the same time I was photographing my mother and for giving me hope by showing me what it is to be a breast cancer survivor.

My mother and I are very lucky to have a number of family, friends and roommates who stood by us through different stages of this experience, namely my brother Ben Clark, my sister Kelly Clark, Niva Clark, Vanessa and Corin Redgrave, Natasha and Joely Richardson, Liam Neeson, Carlo and Jenny Nero, Jonathan and Louise Clark, Caroline John, Daisy Beevers, Susan Smith, Tom Hulce, Julia Rask, the entire cast and crew of *Talking Heads*, the staff of the Minetta Lane Theatre, Jeffrey Lyle, David Ramon, Cynthia Mace, Brandon Maggart, David Lawrence, Reverend Melinda Keck and the congregation of the First Congregational Church of Kent, Tempe Hale, Willow Geer-Alsop, Azura Storozynsky, Eirini Vourloumis, Sara Hines, Scott Shimomura, Anjali Suneja, Jerome Corpuz, Krista Wilbur, Beau Chamberlain, Ryan Palian, Erik Stone, and Nicola Spear.

Most of all, I'd like to thank my mother for trusting me and my camera during the most private moments of her recovery and for allowing me to get to know her even more intimately through the reading and editing of her journal.

Umbrage Editions, Inc.
515 Canal Street
New York, New York 10013
www.umbragebooks.com

Publisher: Nan Richardson
Marketing Director: Amy Deneson
Production Director: Andrea Dunlap
Design Consultant: Emily Baker
Director of Exhibitions: Launa Beuhler
Assistant Editors: Whitney Braunstein, Sarah Bouttier, Kathleen Conn, Jane Kim, Alexandra Krockow,
 Ellen Langer, Terry Roth, and Peggy Struck

Printed in Italy